The Michigan Law Quadrangle

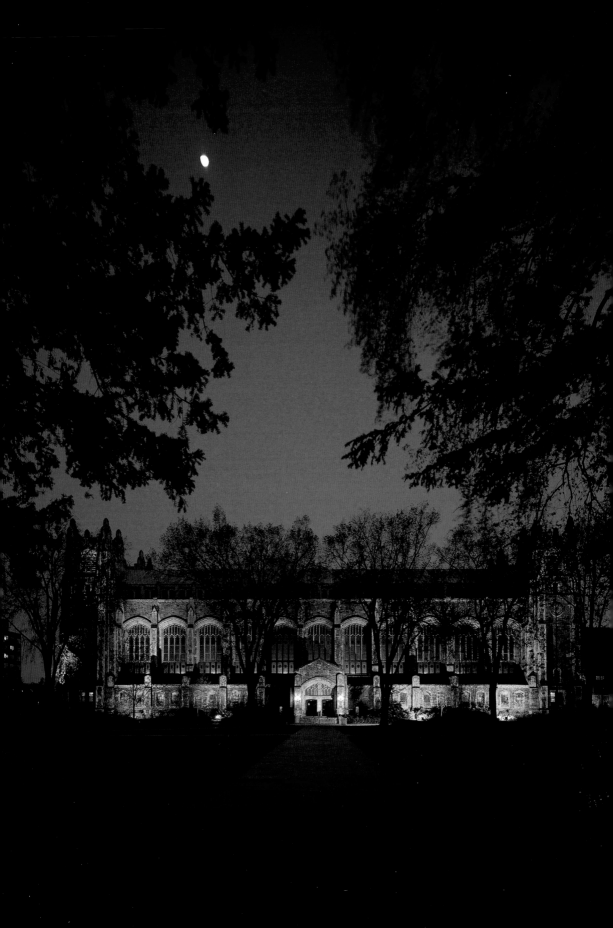

The Michigan Law Quadrangle

Architecture and Origins

Kathryn Horste

Ann Arbor
THE UNIVERSITY OF MICHIGAN PRESS

2000 1999 1998 1997 4 3 2 1

Book design by Wesley B. Tanner / Passim Editions
Printed by University of Michigan Printing Services
Bound by Braun-Brumfield

A CIP catalog record for this book is available from the British Library

Library of Congress Cataloging-in-Publication Data

Horste, Kathryn.
 The Michigan Law Quadrangle : architecture and origins / Kathryn
Horste.
 p. cm.
 ISBN 0-472-10749-6 (alk. paper)
 1. University of Michigan. Law School—Buildings. I. Title.
LD3285.L38H37 1996
378.774'35—dc20
[378.774'35] 96-41351
 CIP

The photographs in this book, unless noted otherwise, were taken by
Gary Quesada.

Frontispiece: *W. W. Cook Legal Research Building at night*

Acknowledgments

This book would not have come into being without the ideas and assistance of persons who are intimately associated with the University of Michigan Law School, and I gratefully acknowledge their respective roles. Lee Bollinger, Dean of the Law School from 1987 to 1994 and then Provost of Dartmouth College, conceived the idea for the project. He recognized that both alumni and the general public would welcome the existence of a guidebook to the Law Quadrangle—one that would describe the buildings inside and out but also recount the history of this unique architectural undertaking of the early twentieth century. His successor, Dean Jeffrey Lehman, graciously continued support for this project.

I would like to extend my warmest thanks to Henrietta Slote, who retired as Administrative Manager of the Law School in 1991 and who, since that time, has worked resolutely to insure that the Law School book would become a reality. Henrietta has supervised and coordinated the project from the beginning, edited the finished manuscript, and has worked to ensure that the photographic illustrations in this volume are of the highest quality. I am most grateful to have had the advantage of Henrietta's incomparable knowledge of the Law School—its faculty, students, and staff, its official history as well as its lore, and all the accumulated things that go on in a complex administrative unit like the University of Michigan Law School but never seem to get recorded.

I would like to thank Joseph Vining, Harry Burns Hutchins Collegiate Professor of Law of the University of Michigan Law School, for reading and offering advice on my manuscript. Similarly, I owe thanks to David Chambers, Wade H. McCree, Jr., Collegiate Professor of Law, for reading my manuscript and offering his advice.

I would particularly like to acknowledge the cooperation and help of Pam Hamblin, Manager, and Brent Terry, a staff employee, of the University of Michigan Facilities Planning and Design Department Print Room, who made possible the study and photographing of the original architectural drawings of the Law Quadrangle in their collection. Acknowledgment is also due to Martha Dunetz, archivist of the St. Albans School, and Tracy Savage, of the Cathedral School, both of Washington, D.C., for their generous assistance with identification of York & Sawyer's Lane-Johnston Building and for their readiness to supply information on St. Albans.

This work was performed under the sponsorship of the Regents of the University of Michigan.

MAY 1996

EDITOR'S NOTE: Buildings that house vigorous organizations undergo frequent rearrangement, renovation, and development of their spaces. Several modifications of the University of Michigan Law School buildings will have occurred between the writing of this text and its publication. A notable example is the opening of the Joseph and Edythe Jackier Rare Book Room within the Library Addition.

Contents

Introduction

The Michigan Law Quadrangle: Architecture and Origins is intended to combine elements of a history and a guidebook. For those students, alumni, and visitors to Ann Arbor who have long admired the sequestered spaces and the noble corridors of the Quadrangle, the book is meant to answer some of the many questions that come to mind about its historical styles and the significance of its rich decorations, as well as to serve as a ready source book for those encountering the Quadrangle for the first time. Chapters 2 and 3 recount the history of the Quadrangle as a construction project and the sometimes complicated dynamics among the donor (and alumnus) William Wilson Cook, the Law School, and the architects York & Sawyer. Based heavily on Cook's personal and business correspondence and on documents from the Office of the Dean of the Law School, this history is meant to reveal what the early parties to the inception of the building plan had in mind and how quickly the Quadrangle idea became concrete. The reader will see that the idea of the Quadrangle complex as a living/learning/professional environment evolved rapidly in the minds of all the principals and quickly became the unanimous goal.

Chapters 2 and 3 are framed by two descriptive chapters that introduce the reader to the Quadrangle from the exterior and the interior respectively. This perspective allows readers and visitors alike to appreciate the multiple ways in which the architecture works its appeal. The viewer can perceive the whole as a beautifully sited and grouped arrangement of buildings and open spaces, as unparalleled examples of the collegiate Gothic style, and as the field for the endlessly inventive play of decorative work in stone and wood, plaster, brass, bronze, and stained glass. Because so many visitors have been, over the years, so drawn to particularly memorable details of the buildings and their decoration, it was decided early in the project that the book should be heavily illustrated.

This book begins, then, with an architectural tour of the Law Quadrangle with references to historic buildings of the Gothic style that lie behind the forms and decorative artistry of this latter-day interpretation.

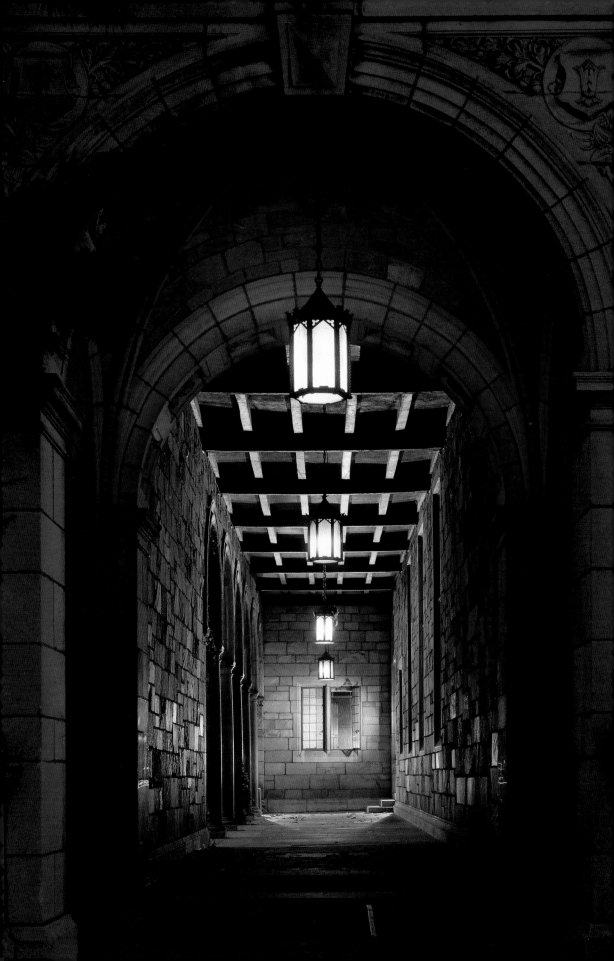

The Architecture of the Law Quadrangle: The Riches of the Gothic Style

Since 1933 the walls of the Law Quadrangle, fashioned in the Gothic style of the late Middle Ages, have protectively concealed their grassy inner courtyard. The Gothic vaults, ribs, glazing, and slender pinnacles make this the most handsome complex of buildings on the University of Michigan campus, as well as the most thoughtfully arranged. Students and visitors alike are drawn to approach the muted granite walls, to pass through them and explore the unknown spaces of the Quadrangle within.

The Vaulted Entrances to the Quadrangle

There are three entrances into the long facade of the Quadrangle that lines South University Avenue. The two smaller entrances at the northwest and the northeast corners are identical to each other. In a manner that adds historical interest to the building, the architects, York & Sawyer, chose to ornament these two smaller openings in a classicizing style. Elsewhere on the interior of the Quadrangle, unexpected touches of classical ornament can be discovered, an eccentricity that adds visual variety and a sense of whimsy. The two smaller entrances through the north wing of the Quadrangle, occupied by the Lawyers Club, consist of round-headed arches opening into a rib-vaulted tunnel. The outer facade of each is very ornate. The arch is framed by fluted pilasters supporting a heavy cornice carrying a rectangular tablet with an inscription. The northeast archway carries these words:

Facing page:
*West entry arch,
north facade Lawyers Club
dormitory*

UPON THE BAR DEPENDS THE CONTINUITY OF CONSTITUTIONAL GOVERNMENT ❧ AND THE PERPETUITY OF THE REPUBLIC ITSELF ❧❧

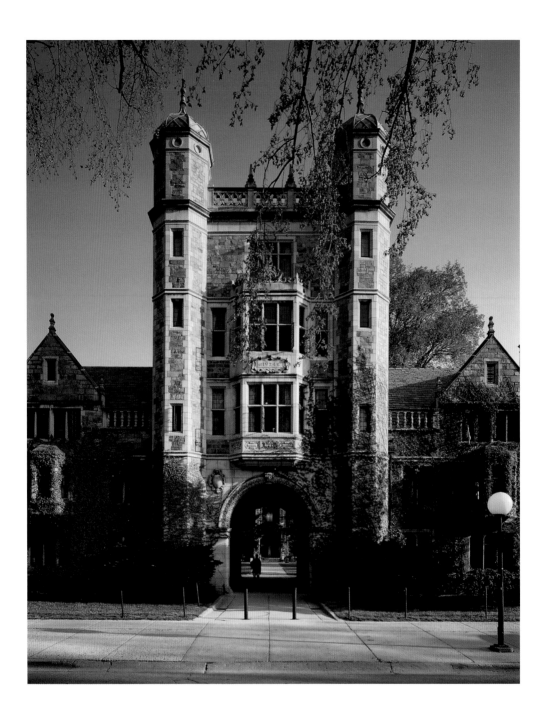

*Tower entrance to
the Law Quadrangle*

The cornice of the northwest entrance reads:

THE SUPREME COURT ❖ PRESERVER OF THE
CONSTITUTION ❀ GUARDIAN OF OUR LIBERTIES ❀
GREATEST OF ALL TRIBUNALS ❖❖

The soffit of each arch carries large panels, each carved with a
fleur-de-lis, a thistle, or a rosette in relief. The roofline of the
Lawyers Club is interrupted by a series of twelve gables;

between these gables the roofline is topped by a simple balustrade.

The main entrance into the Law Quadrangle is the tower entrance on the north side, set in the center of the long dormitory wing of the Lawyers Club and opening into the Quadrangle from South University Avenue. The four-story tower resembles an imposing gateway through a fortified wall, some sixty-five feet high. It has octagonal turrets at each corner with crowning cupolas, connected by a decorative stone balustrade. The tower roof is a low cupola. The entire structure has been compared to the entrance to Clock Court in Hampton Court Palace, London, above all because of the four turrets rising from the corners. Yet this type of massive gateway entrance was common in English Medieval architecture. Its primary features were standardized from an early date: the massive, blocklike design with round-headed entrance passage, the military associations of the fortifying walls, and the emphasis given the four corners by turrets. Elements can be found in English civic and church architecture, as well as in grander domestic buildings. At Charlcote in Warwickshire, for example, the Elizabethan country manor of the Lucy family, the great sixteenth-century freestanding gatehouse has many design elements recalled by the tower of the Law Quadrangle—octagonal corner turrets with cupolas (but only at two corners), the round-headed entrance arch with projecting bay window above, and the perforated stone balustrade running continuously around the top. Even so, the gatehouse at Charlcote, in rose-colored brick, is far more sober than the design at Michigan and is essentially rectangular in plan, without the vertical emphasis.

In fact, it is doubtful that the gateway at Michigan copies any individual building. Rather, its design was more likely to have been put together from salient elements of the English Medieval ceremonial gateway as a building type. As for the miniature cupolas crowning the corner turrets and the one over the central tower, these have been repeatedly referred to as Byzantine. In fact, they have nothing to do with that East Christian style. The cupola and turret combination has its own tradition in English Gothic architecture, going back to Norman Romanesque practice and from there to the Conti-

nent, to Carolingian (ninth- and tenth-century) architectural design.

Even though the tower entrance is the largest, it is not as ornate as the smaller entrances. It is simply decorated with a few traditionally classical motifs—the egg and dart and the scallop shell on the arch molding—and it has no fluted pilasters. Higher up on the tower, topping the bay windows of the second and third stories, are Renaissance-style swags and a rectangular panel inscribed with the year 1924, the year of completion of the Lawyers Club. More details of Renaissance style appear on the northwest corner of the Quadrangle, immediately next to the small northwest entrance. Here the west wing of the Lawyers Club terminates in a giant bay window of two stories topped by a classical balustrade and decorated with other motifs immediately suggestive of the Renaissance—oval and circular forms and stone swags simulating precious cloth.

Returning again to the main entrance gate, perhaps just as interesting as its architectural details is its location. It is positioned directly across from the main entrance portal of the Law Library, so that the first sight the visitor sees upon emerging from the entrance arch is the portal into this most important building of the complex. This deliberate positioning of the two openings at opposite compass points also helps visitors to orient themselves when first entering the vast space of the Quadrangle. Interestingly, a hand-drawn plan of the projected quadrangle prior to its construction, prepared in 1921 by Henry M. Bates, dean of the Law School, at the request of the architects, shows that Oakland Avenue once cut straight through from Monroe Street to South University Avenue across the tract of land that now forms the inner court of the Law Quad. This suggests the possibility that the grand entrance tower to the Quad on South University Avenue was meant to preserve the memory of the old termination of Oakland Avenue. While only a conjecture, it is common practice in all periods for new buildings to be constructed on physical sites that have been given significance of some sort by having been previously occupied. It is not unusual for physical remnants of a previous building to be incorporated into a new structure on the same site, usually for some symbolic or commemorative reason. Likewise, care is often taken to pre-

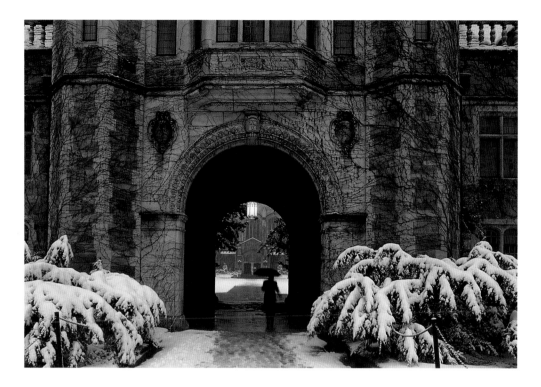

serve the physical relationships of an ensemble of buildings when it becomes necessary to replace them. In the case of the main entrance into the Law Quad, its architectural form—that of a triumphal arch with a throughway passing beneath it—is itself a commemorative form. It seems, therefore, not unlikely that the fixing of its location could have been influenced by the pattern of Oakland Avenue as it existed in the 1920s but was effaced by the Quadrangle.

As soon as visitors pass through the classical arch on the exterior of the main entrance, they are inside a Medieval world. The portal forms a high tunnel, vaulted in stone and with the familiar ribbed construction associated with the Gothic style. The type used in the Law Quadrangle entrance is known as a ribbed groin vault. The development and use of the rib was one of the most important technical innovations of Medieval builders. It allowed them to construct and to center a stone skeleton of ribs that was flexible enough to roof over a variety of rectangular and other geometrically shaped spaces and then to fill in this skeleton with thin segments of vaulting stone. The ribbed vault roofing over the main

7

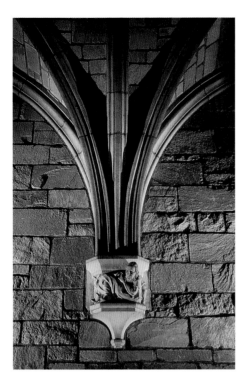

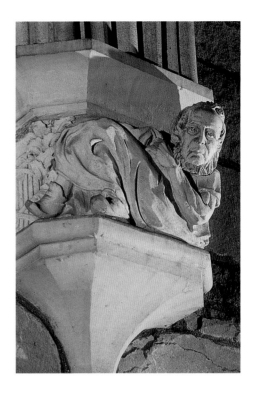

Above:
Corbel with caricature of President Tappan

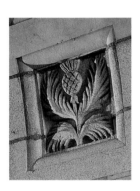

entrance into the Quadrangle is a very authentic approximation of a Gothic vault, made up of two bays, or spatial units, defined by the white limestone ribs, the convergences of which are marked by heavy floral bosses.

Sculptured Corbels

Perhaps the most popular bits of Gothic-style decoration in the entire Law Quadrangle are the amusing sculptured figures who crouch beneath the weight of the vault ribs on the interior of each of the three entrance passages into the Quad. The first time the visitor becomes aware of their presence is an occasion of delight. Set only slightly above eye level, the unexpectedness of their presence is part of their fascination. This type of sculpted figure is common in Gothic architecture, where it is referred to as an Atlas figure (plural atlantes), a crouching male who appears to support some architectural member on his back, in this case the cul-de-lampes or corbels serving as terminations of the vault ribs. The subject matter of the atlantes of the Law Quad authentically captures the character of Gothic

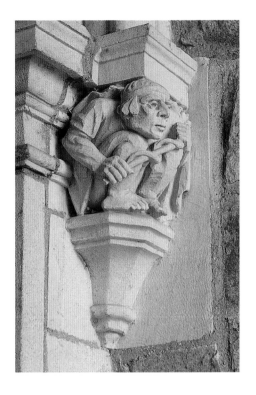

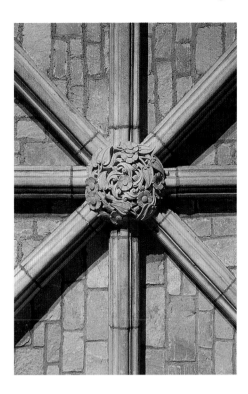

figures because it combines the allegorical, the crudely amusing, and the grotesque. The figures are conceived in groups representative of the seasons and various activities of university life. For example, the northeast entrance contains figures alluding to the seasons—Winter as a grotesque bearded old man—as well as seasonal sports, such as ice hockey. The professions are represented, in both the northeast and northwest passages, by allegorical types of the architect, the engineer, and the man of medicine. The main entrance is the favorite of visitors, however, because six of the atlantes wear the facial features of prominent University of Michigan presidents of the past and can be easily identified as such. All six University presidents who had served up to the time of construction of the Lawyers Club were included in the ensemble: crouching Presidents James B. Angell, Harry B. Hutchins, and Marion L. Burton face similar images of Presidents Henry P. Tappan, Erastus O. Haven, and Henry S. Frieze, all astonishingly portraitlike and only slightly caricatured. This entrance also features seasonal activities, such as grape gathering, grain harvesting, and football.

Detail, stonework entry arch to Law Quadrangle, Atlas figure representing Medicine

The Buildings of the Quadrangle

Because there are so many details to pause and attend to at the main entrance through the gatehouse, visitors are left unprepared for the vast and unroofed space that suddenly opens before them as they pass into the interior of the Quadrangle. This long and wide space is enclosed on four sides, with the exception of the southeast corner, yet it is open to the sky. It suggests a place at once sequestered and protected but where thought is free to take flight. Once inside the Quadrangle, the visitor will remark how differences in height and in richness of detail create noticeable variations among the buildings, appropriate to their different functions. The English Gothic style is the unifying element of the vast architectural grouping. In

numerous early handbooks this style has been called Tudor, a style that describes some English buildings under the influence of the Tudor monarchs, who reigned from 1425 to 1600. Hence the style overlaps both the late Middle Ages and the Renaissance in England. *Tudor,* in fact, is a term more appropriately applied to domestic architecture, such as the country manor or the town house. It is probably suitable to describe the dormitories of the Law Quad. The most prominent structures of the Quad, however, the great Dining Hall and the Legal Research Building, are modeled on collegiate and church architecture. It is more correct to identify these buildings using the stylistic term customary for this architecture of grand scale in England—the Perpendicular style. We will say more about this style as the buildings are described later in this chapter.

In approving the Gothic style for the Law Quadrangle, the University of Michigan was embracing a movement that had already been underway for some decades in American campus architecture. Yale's campus included Victorian Gothic buildings constructed prior to the Civil War, and Trinity College in Hartford, Connecticut, had a Gothic plan in design by 1878. Nevertheless, the real vogue for Gothic on college campuses began in the early 1890s, stimulated by the World's Columbian Exposition of 1893 in Chicago. At this same period the University of Chicago drew up a plan, under the architect Henry Ives Cobb, to construct an entire campus in the Gothic style, based around a quadrangular plan, "for orderly growth." The positive choice of the Gothic style has frequently been seen as a deliber-

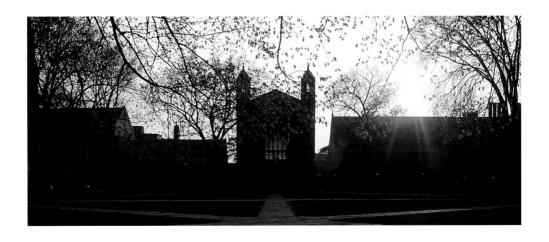

ate rejection of Classical design as well, with its associations of European nobility and the materialism of the Renaissance. The enthusiasm for Gothic was not universal, nevertheless. For some critics it was almost ludicrous to see scientific and technical buildings, such as chemistry or dental labs, in Gothic design. In the case of Michigan's Law School, of course, that style is perfectly suited to the function it was asked to play, to represent a single endeavor—the law—within a closely planned complex of buildings. Furthermore, the Gothic of the University of Michigan is not the same Gothic as that of Chicago. The Law Quad buildings have none of the austerity of the quadrangle at Chicago. Despite the giant proportions of the Legal Research Building and of the open Quadrangle itself, there is a sense of human scale within the Quadrangle at Michigan, because of elements such as the positioning of the decoration within eye view and the smallness of the doorways.

The first portion of the Law Quadrangle at Michigan to be constructed was the Lawyers Club (which opened in the fall of 1924 and was dedicated the following June), occupying the north and west wings of the Quadrangle. The dormitories extend along South University Avenue for 445 feet. The great central entrance tower also contains suites of student rooms. The three-story building has a peaked roof broken by gables. Tall chimneys grouped in fours rise above the roofline. The extended wing of dormitories is composed of nine sections, each of which has its own entrance identified by a wrought iron and glass lantern marked with the section letter. This portion of the dormitory provides accommodations for 197 residents.

The Lawyers Club building proper occupies the northwest corner of the Quad and extends 275 feet along State Street. This group of common rooms was designed to fulfill the visions of William W. Cook and the Law School faculty for a place where law students living in the residence halls could from time to time make professional and personal contact with active members of the bar—visiting lawyers and law faculty who might be staying and dining in the club. Toward this end a spacious lounge, the main gathering room of the Lawyers Club, was located on the first floor. It is decorated in an English Renaissance style that makes it somewhat later

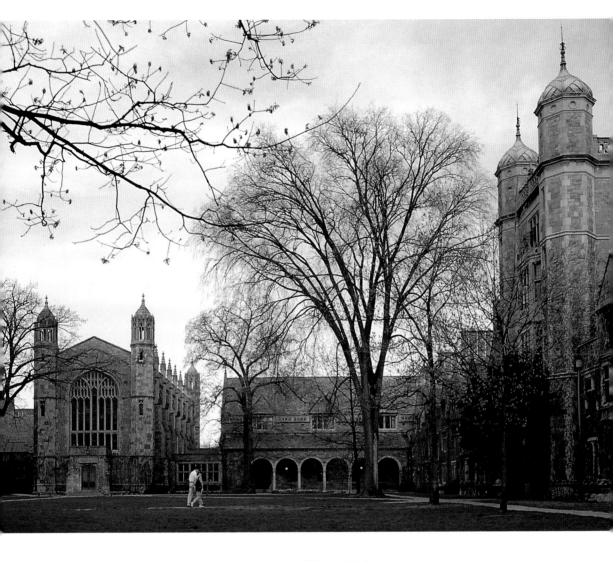

The Dining Hall and cloister, seen looking west across the Law Quadrangle

than that of the exterior architecture (more will be said about this in the "walk-through" of the interior in chapter 4). Eight commodious guest rooms on the second floor are provided for visiting speakers and scholars. Opposite the lounge, separated from it by a spacious lobby, is the great Gothic Dining Hall, one hundred forty feet long and thirty-four feet wide. The hall seats three hundred diners and is a self-contained, free-standing building lying perpendicular to the long axis of the west arm of the Lawyers Club. In its overall design it closely resembles the Legal Research Building, though with reduced proportions. The rectangular, flat-ended plan of both buildings, which lends them a cofferlike design, is accentuated by the octagonal corner turrets and the rows of highly ornate pinnacles that prolong the vertical lines of the buttresses.

13

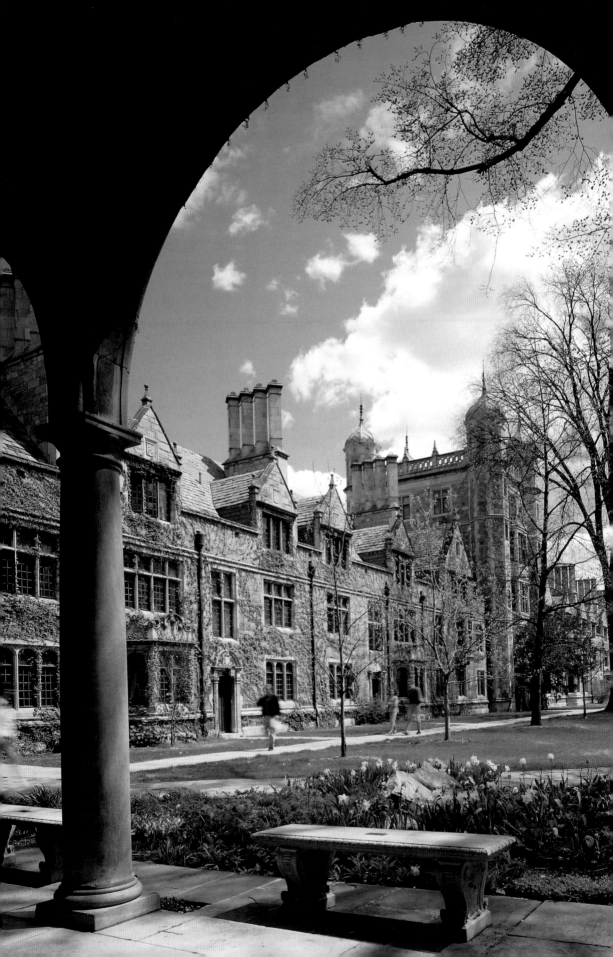

Running along the east facade of the Lawyers Club and forming a covered approach to the entrance into the west wing, is a beautiful arcade (sometimes called The Cloister), composed of roundheaded arches supported on sober Doric columns. The classical forms of this Renaissance-style arcade distinguish it at once from the overwhelmingly Gothic appearance of the exterior of the Quadrangle. York & Sawyer used other Renaissance features fairly liberally on the exterior of the dormitories, but there the elements were used as surface features in a decorative context, as in the architectural framing devices around the arched passages into the Quadrangle from South University, already described. Another instance is door F in the south facade of the Lawyers Club dormitory, where fluted pilasters in classical mode frame the portal, with its Renaissance-style

Facing page:
South facade of Lawyers Club Dormitory seen from the cloister

15

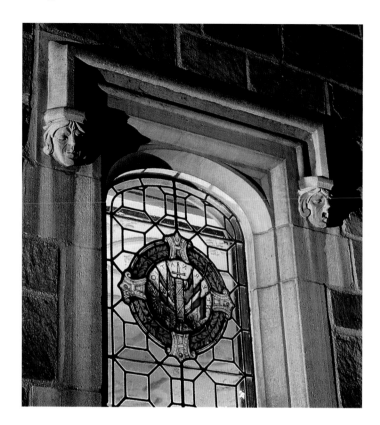

*Window moldings
with sculptural heads,
John P. Cook Dormitory*

lunette above. The arcade, on the other hand, stands out because the architects have used the Renaissance style in structural fashion. The result is an example of the serendipity and tranquil coexistence of successive building styles that characterizes many European collegiate complexes constructed over time.

The John P. Cook Building, a four-story dormitory, was the second portion of the Quad to be built, opening in fall 1930. It is contiguous with the Lawyers Club dormitory wing but rises a story higher. It runs for 212 feet along Tappan Street, at right angles to the Lawyers Club. It accommodates 152 residents, making provision for a total of 352 students between the two dormitories. The Cook dormitory, like the Lawyers Club, is constructed as a series of sections, and in nearly every other way it closely follows the architectural style of the Lawyers Club. The single exception is the elaboration of the sculptural detail on the exterior of the Cook Building. Unlike the windows of the Lawyers Club, which are framed with simple moldings, the

windows of the Cook Building have moldings that terminate in grotesque heads. An accurate approximation of late-Medieval sculptured ornament, these heads show a sequence of pained expressions, such as howling, grimacing, or crying out in terror. Some wear heavy spectacles resembling goggles. At least a few of the heads are duplicates, confirming what is already known about the use of plaster models as guides for the sculptors. Though these heads are a relatively small detail, they clearly distinguish the Cook wing of the Quad from the earlier Lawyers Club and indicate a certain development in the use of Gothic-style ornament as the building project progressed. Certain adjustments were made on the interior of the Cook dormitory, too; the rooms are larger and they have more comfortable appointments.

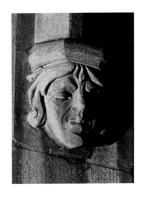

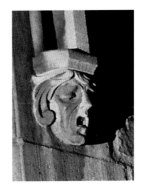

Forming the south side of the Quadrangle is the William W. Cook Legal Research Building (commonly called the Law Library), completed in 1931. The size of the building and the beauty of its architecture make it the dominant structure on the Quadrangle. The Legal Research Building has a three-story elevation, but its proportions are so massive that it dwarfs the four-story Hutchins Hall adjacent to it. Its design is essentially that of a rectangular hall, constructed in length by a series of repeated bays (spatial units marked off from each other on the exterior by thick, projecting buttresses). The wall area between the projecting buttresses is opened up with long tracery windows. The four corners of the building are emphatically reinforced by massive rectanglular towers, also buttressed, and topped by vestigial blunt pinnacles. The building is 244 feet long, 44 feet wide, and 50 feet high (on the interior). The stack portion of the building was originally six levels in height. In 1955 the stack structure was increased to ten levels, allowing for a capacity of 350,000 volumes. In 1981 a new four-story subterranean library with a 77,000-square-foot capacity was added to the Law Quadrangle complex, designed by Gunnar Birkerts. This striking modern structure was freed of any necessity to accommodate itself to the existing Quadrangle by its hidden, underground profile.

The final unit of the Law Quad, Hutchins Hall, opened for use in fall 1933. This four-story building is named for Harry B.

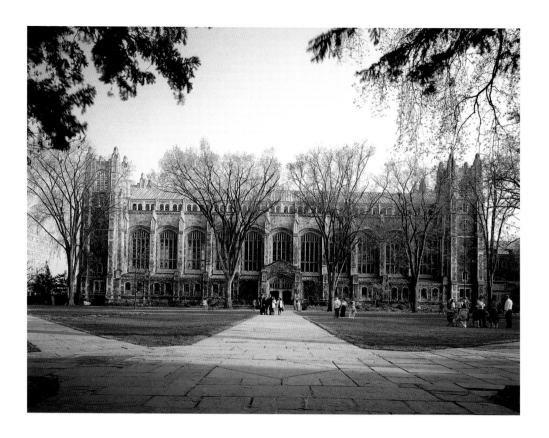

Hutchins, dean of the Law School from 1895 to 1910 and president of the university from 1909 to 1920. It forms the northeast corner of Monroe and State Streets with entrances on both streets. It was constructed to house the faculty and administrative offices of the Law School and to provide the lecture and seminar rooms for Law School classes. Stylistically it resembles the dormitory wings of the Lawyers Club and the Cook Building, with its gabled roofline. A few elements allude to the Perpendicular style of the Dining Hall and the Law Library, but these details, such as the small tracery windows and the projecting buttresses that rise only to the first story, have the character of artificial additions rather than of functioning architectural members. The main entrance opens onto the Quadrangle. From here one can see the magnificent west end of the Legal Research Building. The entrance to Hutchins Hall is a double portal in late Gothic style framed in broken Gothic arches and fading moldings. The double doors carry a massive entablature above, with the name of Hutchins Hall and with late-Gothic applied tracery in stone over the surface of the entablature. Hutchins Hall is four stories high, but the corridor into which

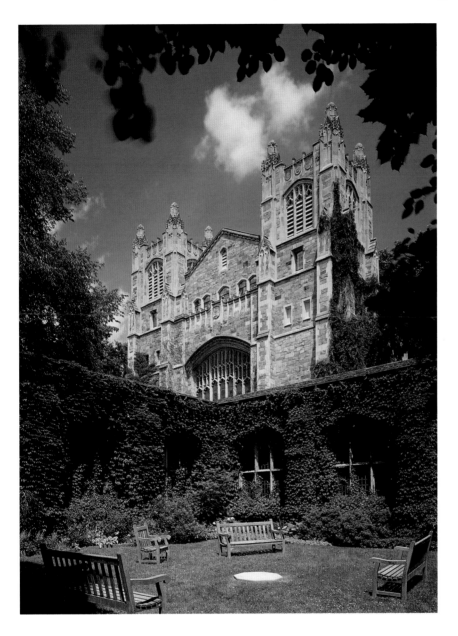

the main entrance opens is only one story. This has allowed for the creation of an enclosed cloisterlike space at the center of the plan of Hutchins Hall. This beautiful unroofed space, rich with foliage and a grassy carpet, is visible from the the east, north, and south corridors of the first floor and can be entered from doorways in the east and north. Occupants of the building can look down on it from the south corridor of the second floor (looking northward) and from windows at all levels of the west

Enclosed "cloister," of Hutchins Hall, with west end of Law Library in the background

19

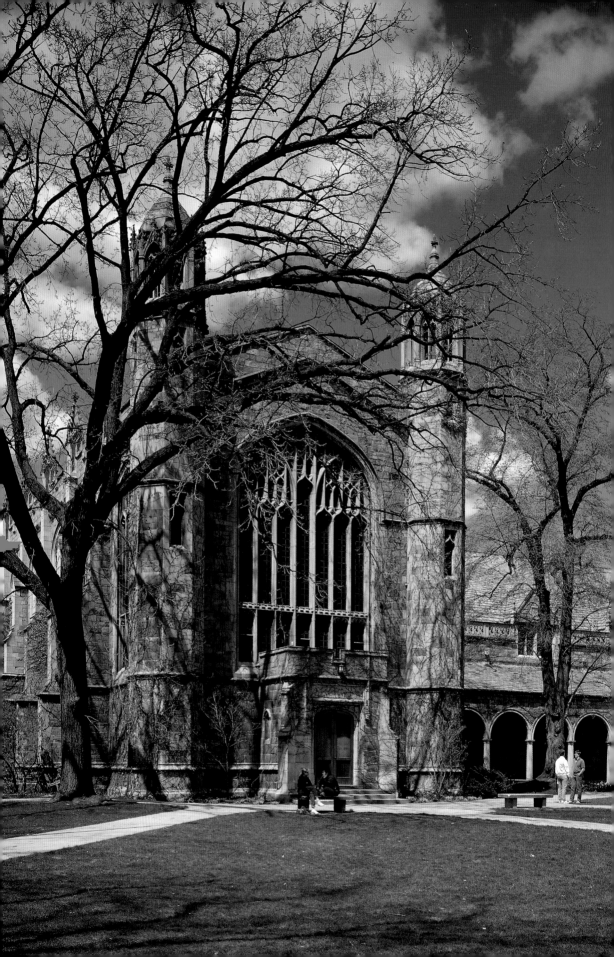

stairway of the building, as well as from north- and east-facing offices on the third and fourth floors.

Sources in English Gothic Architecture

As a unified architectural complex, the Law Quadrangle belongs to the tradition that began with the quadrangle of Saint Mary's College of Winchester (called New College) at Oxford. This collegiate foundation was established in 1379 for the purpose of training clergy for an active life in the Church and government. It could house seventy resident students and was the earliest English college to employ a quadrangular design. Based on the much earlier building type of the monastic cloister, New College at Oxford forms a rectangle open to the sky but completely enclosed by the buildings that define it on all four sides. Access is through a monumental gateway, as in the Quadrangle at Michigan. Buildings of various functions are arranged around the sides of the quadrangle: the chapel, the hall, the dormitories, the library, and the bursar or treasurer's rooms.

This quadrangular design proved to be so functionally ideal for its purposes that it was adopted as a traditional collegiate design literally for centuries on the Continent. In America its introduction was tied to the vogue for the Gothic style at the end of the nineteenth century and early decades of the twentieth. The success of the quadrangle lay in part in its being the perfect urban solution, creating a cloistered world of its own where students and faculty could follow their scholastic pursuits together while sheltered from an active urban environment.

While inspired in its traditional design by New College, Oxford, there is little in the individual buildings at Michigan that resembles the buildings of Oxford. Instead there are other notable buildings of the late Middle Ages in England that seem to have supplied models for York & Sawyer's designs. As noted above, the Law Quad follows the period style called the Perpendicular. The style takes its name from the tracery patterns of the enormous windows favored in this style. It is characterized by tall, narrow panels of glass defined by perpendicular shafts of tracery. The name "Perpendicular" refers not only to the

Facing page:
*The east end of
the Dining Hall*

21

dominance of upright, repeated vertical lines within the style, but also to the extremely steep, precipitous character lent to the windows and to other decorative elements by use of this linear grid. The effect created is much more screenlike in its linear emphases than were earlier window designs, with their predominantly curvilinear patterns. The great east window of the Lawyers Club Dining Hall, the extended sequence of windows on the north and south facades of the Law Library, and even, in a much simplifed interpretation, the windows of the ground story of Hutchins Hall, were all created according to the principles of Perpendicular style.

The overall architectural plans, as well as the monumental window treatment of the Law Quad buildings, can be seen to borrow from any number of late Gothic buildings in England—cathedrals, abbeys, parish churches, and chapels. The Dining Hall has been frequently compared to the famous King's College Chapel at Cambridge and this is, indeed, the English Gothic building it most resembles. Under construction from 1446 to 1515, the chapel is rectangular and elongated in plan, like the Lawyers Club Dining Hall, but it is nearly 300 feet in length—three times the length of Michigan's version. The facade of Michigan's Dining Hall has all the features, in similar proportions, of the great east facade of King's College Chapel, with its pair of soaring octagonal turrets anchoring the corners of the building and its great screen wall almost entirely of glass dwarfing the entrance portal. But the modern interpretation at Michigan is notably simplified. The octagonal turrets of the Dining Hall rise only one story above the corners of the facade, and their cupolas, while delicately ornate, do not approach the intricacy of perforated stonework in the Gothic turrets of Cambridge. The facade at Michigan lacks the ornate balustrade defining the gabled roof. Also notable is the simplicity of the portal opening in the east facade of the Dining Hall. It has a spare architectural frame enclosing a shallow late-Gothic arch and with a carved inscription

FREE INSTITUTIONS ❁ PERSONAL LIBERTY

above the opening as the only ornament. The portal of King's College Chapel, in contrast, is richly decorated, enframed by applied Perpendicular tracery and figurative sculpture above a

Facing page:
Turrets, pinnacles, and buttresses, Dining Hall

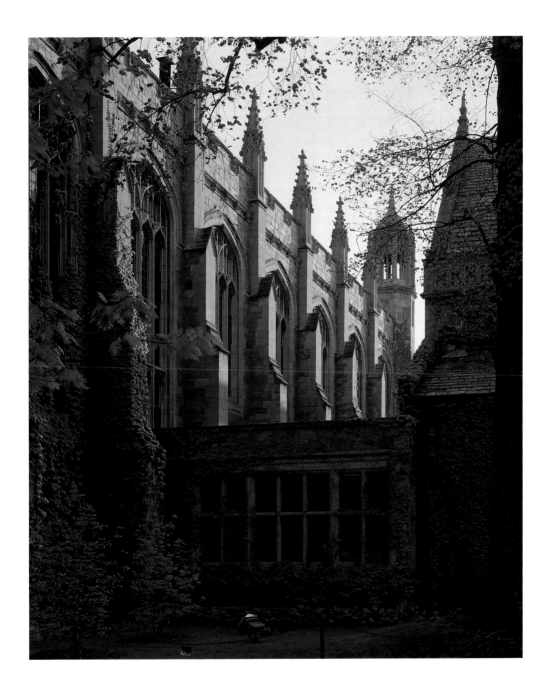

traditional pointed Gothic arch. Along the longitudinal flanks of the Dining Hall, it can be seen that the vertical buttresses dividing the bays are quite shallow, while those of the Cambridge Chapel project forcefully. The Dining Hall does follow the model at Cambridge in the horizontal row of ornate pinnacles extending the lines of the buttresses above the roof.

Clearly, then, the Dining Hall of the Law Quad is only an approximate replica of the great chapel of King's College. In

fact, the design of the building in the form of an elongated hall and, especially, the design of the facade, were hardly unique to King's College Chapel. The Perpendicular west facade of Beverley Minster in Yorkshire, for example, has all the elements of the facade of King's College Chapel in an earlier form, while being much more richly decorated with sculpture. Furthermore, the tracery pattern of the great east window of the Law School's Dining Hall more closely resembles that of Gloucester Cathedral than it does King's College. The window of the south transept of Gloucester has been called the earliest surviving example of the Perpendicular style, dating about 1335. It is considered early because the Perpendicular tracery patterns have not absorbed the entire window as they were to do in examples from later in the century. Perpendicular patterns do appear in the lower half, but the upper half is defined by demi-arches and pairs of window lights that belong to earlier tracery patterns. A close look at the east window of the Dining Hall of the Law School shows the same presence of vertical and curvilinear tracery patterns. York & Sawyer here achieved a very sophisticated interpretation of an early Perpendicular-style window.

The design of the great Legal Research Building approximates closely to that of an English Gothic cathedral. The exterior displays the three-part elevation that was typical of English Gothic construction. On the ground story the architects have inserted low "chapels"—each with a pair of windows—between the strongly projecting buttresses, in the manner of King's College Chapel, Cambridge, with its chantry chapels along both flanks. Above this story of the Legal Research Building are the enormous windows that correspond to the triforium of an English cathedral. These replace a great deal of wall space and were especially chosen, according to Edward York, so as to let in as much light as possible (they correspond, on the interior, to the upper walls of the Reading Room). The triforium windows have a tracery pattern more purely Perpendicular in style than the east window of the Dining Hall. In these windows the vertical bars of tracery run all the way up the window, as though terminating beyond the top of the arch. No arched or curved patterns are present. The small clerestory, stunted in comparison to

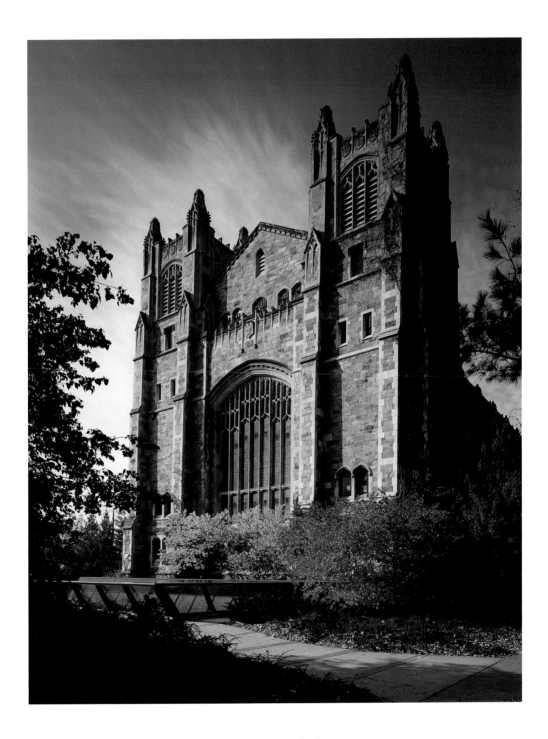

the enormous triforium, indicates that the central hall carries a flat wooden roof over the main space, not the ribbed vault of a French Gothic cathedral. Finally the great blocky towers that mark the four corners of the building also contribute to the English Gothic flavor of the building. Their short proportions, thick-walled construction, massive buttresses, and square plan

all are reminiscent of Norman construction that was characteristic of a much earlier period of English building. Towers were among the conservative features of English Medieval design and the authentic Norman qualities of the towers of Legal Research show the sensitivity of the architects to the history of the English Gothic style.

Another conservative feature is the low, sprawling ground plan of the Legal Research Building. While French Gothic architects experimented with greater and greater height in their cathedrals, their English Gothic contemporaries continued to favor the low profile traditional in England. The freedom with which York & Sawyer treated this building type, even while seeking authenticity in many details, is apparent in the way they placed the main entrance into the library on one of the longitudinal facades of the building. By doing so they gave the building an entirely new axis that would allow it to form one long wing of the Quadrangle. In actuality the main entrance would never have been placed here on a Medieval cathedral. The main entrance was always on one short end of the building, toward the west. A visitor entering the building would see an extended tunnel of space that projected away, into the distance, toward the opposite east end of the building. In the Law Library at Michigan, space extends equally to right and left as the visitor enters the Reading Room, creating a sense of expansive space to either side but without the sense of focus created by the longitudinal axis.

One of the most striking things revealed by our visual tour of the Law Quadrangle is how historically authentic the buildings are in their exterior qualities and their decoration. From the ground plans and elevations to elements as fine as window tracery, doorjamb moldings, and elements of sculpture, the Law Quadrangle as a whole reveals a remarkable sensitivity to the late Gothic style, and specifically the English Perpendicular. The architects and draftsmen who built these buildings show an impressive confidence in working with the elements of the style that goes beyond a mere copying of selected Gothic models. Rather, it appears that the builders were sufficiently knowledgeable about the fine points of Gothic architecture that they were able to create new designs and new combina-

tions of decorative features infused with the true aesthetics of the Gothic style.

Did the draftsmen, stonemasons, and sculptors of the Law Quad gain such knowledge of the Perpendicular style and its fine points from firsthand study of churches, cathedrals, and chapels in England? That is highly unlikely, although York and Sawyer themselves, as coheads of the firm, were well-traveled and broadly educated humanists. For draftsmen and masons who probably did not have such exposure to Gothic monuments, there was a type of publication, extremely popular in the nineteenth century, that would have amply filled the need for concrete models and that would have been part of the library of any practicing architectural firm of the early twentieth century. We are referring to such publications as those of the architect Augustus Welby Pugin, who was active in the first half of the nineteenth century and whose passion was Gothic architecture of the thirteenth and fourteenth centuries. Among Pugin's many publications, books such as *Examples of Gothic Architecture; Selected from Various Antient* [sic] *Edifices in England . . .* (London, 1821; revised edition 1831, 2 vols.) are full of structural and decorative details that are archaeologically exact. The *Examples of Gothic Architecture,* for example, highlights Gothic buildings of Oxford and Cambridge. Page after page shows cross-sections, elevations, and profiles, window tracery, pinnacles, buttresses, cornices, window mullions—all with dimensions and with scales in feet. In other words, the book contained all the details that a draftsman would need to construct a Gothic-style doorway, or any other element, in the absence of access to a Gothic building itself. *Examples of Gothic Architecture* happens to contain several drawings suggestive of York & Sawyer's Michigan Quadrangle. The frontispiece, showing the west front of the Great Gateway of Magdalen College, Oxford, closely recalls the main entrance and, especially, the interior wall of the entrance into the Legal Research Building with its bust-length angels terminating the cornice to either side and the Perpendicular wall tracery above. Likewise, plate XLVI, a detail of King's College Chapel, Cambridge, reveals the similarities in details in the turrets, gables, and cupolas to the decorative details of the Dining Hall at Michigan.

The Michigan Law Quadrangle

These observations are not meant to imply that the drafts-men and carvers of the Law Quad necessarily studied the books of Pugin; they would have had access to many such professional publications of the nineteenth century. Rather, the way the Law Quad looks and the way its architectural details have been put together suggest a mode of working by York & Sawyer and their contractors in which any number of illustrated architectural books could have been consulted and their respective drawings used as the basis for constructing new architectural designs, rather than as static models to be copied.

A visitor entering the Law Quad cannot help but be exposed to its beauty, its sense of timelessness, as well as to the whimsy of unexpected details. But an observer with keen attention and eyes wide open will also learn much about how the buildings were constructed and how distinctive they are in decoration.

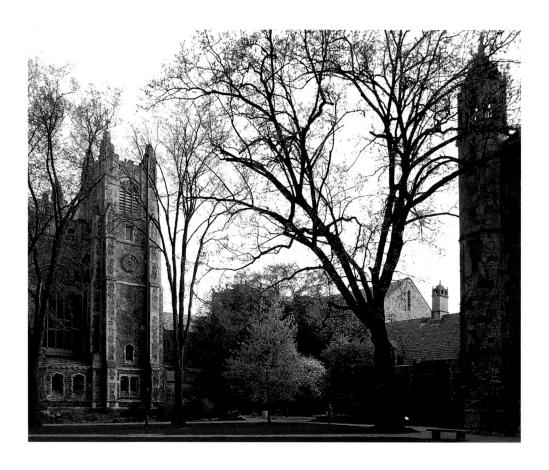

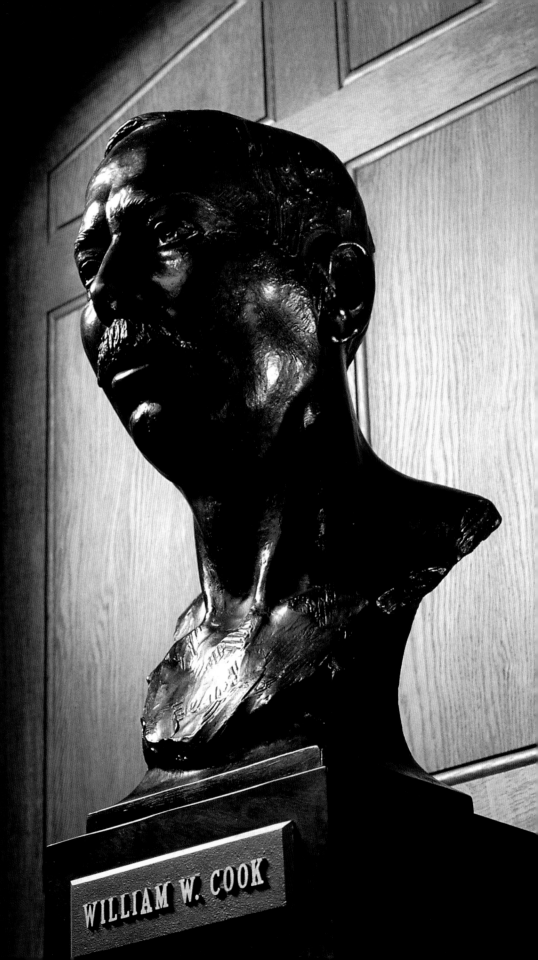

WILLIAM W. COOK

History of the Building Project: The Law School Finds a Donor

The making of a memorable building is always an act of collaboration. The client, the sponsor, the architect, and the builders all take a more or less proprietary interest in the outcome. In addition, there are the prospective users of the building, who are usually eager to be consulted. With so many different heads involved, it is often difficult to say with finality who was responsible for particular decisions in the complex and evolving process of architectural planning. Where the Law Quadrangle is concerned, it would be satisfying to know whose inspiration impelled the project in one particular direction and not another. Who made the design choices, large and small, and was there perfect harmony among the interested parties as these decisions were made? Did the builders follow the architectural plans in every particular, or did they find it necessary to adjust certain features as the dynamics of construction unfolded?

The Origins of Cook's Donation

The following history of the Law Quadrangle will attempt to recover, as far as possible, the process of decision making that produced the distinctive grouping of buildings that rises on the south-central campus today. As in the history of any collaboration, there can be frustrating gaps in the written record, if only because certain information tends never to be committed to paper. Fortunately, in the case of the Law Quad, many important discussions and exchanges did leave a record, since most of the work of problem-solving had to be carried on at a distance.

William Wilson Cook, University of Michigan Law School alumnus and the donor of the buildings, had his legal practice in New York. Surprisingly, he never visited the Law Quadrangle

Facing page:
Bronze bust of Cook by Georg J. Lober in the Reading Room of the Law Library

himself, either during or after completion of any of its buildings, and he turned aside all urgings that he do so. What is more, he chose a New York architectural firm to design the buildings, a prominent firm whose work fell within his own East Coast sphere of acquaintance. The architects, of course, repeatedly visited the building site at Ann Arbor and met when necessary with Law School administrators in New York or at Cook's country home at Port Chester. Even so, the urgent nature of many decisions required the principals to be in constant contact with each other by telegram and letter—sometimes daily by return mail. The official history of the Law Quad enterprise preserved in university records and proceedings is brought to life by the immediacy of this other, more personal, correspondence, revealing, as it does, the hopes and objectives of donor, university, and designers from the very beginning of the project.

The existing Law Quadrangle, embracing two entire blocks of the south-central campus, is the successor to an earlier building once located in the northwest corner of the campus that had housed the Law Department since 1863. That building had been enlarged in 1892 and again in 1898. The earliest official indications that the Law School was once again straining the capacity of the nineteenth-century building are contained in the *Proceedings of the Board of Regents* of 1919. At the November meeting of that year the regents were presented with a report on "the necessity for larger and more suitable quarters for the Law School, including the Law Library." The current high cost of building was noted in the report, and the board resolved not to draw on the university's general fund to undertake new construction. In fact, labor and construction costs had shot upward since the beginning of the First World War, and new projects were being delayed in many regions of the country with the expectation that wages would eventually fall to pre-war levels. If the university's general fund was not to be tapped, only two other options were available to finance needed building expansion for the immediate future—to request special action by the Michigan Legislature or to locate private donors.

Fortunately for the Law School, such a donor was soon forthcoming. At the meeting of 19 September 1921 of the Regents' Committee on the Comprehensive Building Pro-

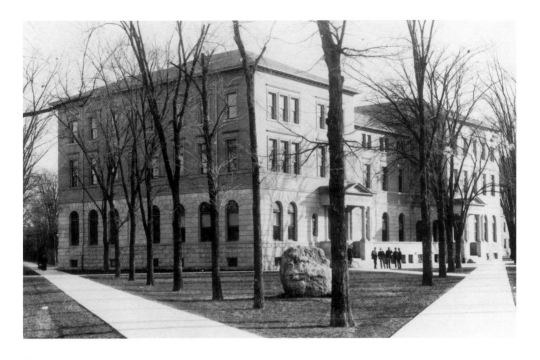

gram, University President Harry B. Hutchins disclosed for the first time that an alumnus then residing in New York City—who wished to remain anonymous—had communicated in confidence his intention to construct a new law building and one or more residence halls for law students (referred to in subsequent resolutions as the Lawyers Club building).

Previous home of the Law School, as remodeled, 1897

The source of this unprecedented offer was eventually revealed to be William Wilson Cook, a graduate of the Law School, class of 1882. Cook was born in Hillsdale, Michigan, 16 April 1858, the son of John Potter Cook and Martha Wolford Cook. He attended public schools in Hillsdale and the preparatory department of Hillsdale College. He entered the University of Michigan in 1876 and received his bachelor's degree in 1880. Two years later he graduated from the Law School. He then entered the New York firm of William B. Coudert and was admitted to the New York bar in 1883. In the Coudert office he rose to the level of a very successful and influential corporate lawyer, as well as a prominent writer on legal matters. Among his publications were widely read books on corporate law and on the character of the legal profession. He served as general counsel for many years for the Commercial Cable and Postal

Telegraph Company. In 1921 he retired from practice to devote himself to his research and writing. By 1924 Cook's fortune was estimated at between twenty and thirty million dollars. After a brief marriage that ended in divorce, he lived alone, dividing his time between his New York townhouse and his ninety-seven-acre estate at Port Chester, New York, just north of Rye.

Dean, later President, Harry B. Hutchins

Henry M. Bates, dean of the Law School from 1910 to 1939, had been a party to the early negotiations between the university and Cook, frequently representing the Law School's interests when President Hutchins was unable to be present. Dean Bates's recollections of Cook's plans to benefit the Law School and of how these evolved over a period of years are contained in *A Book of the Law Quadrangle at the University of Michigan,* a commemorative volume issued to celebrate the completion, in 1934, of the last of the Law Quadrangle buildings, Hutchins Hall. According to Bates, while Cook was still a young lawyer—sometime around 1908—he had made provision in his will to endow a chair in corporate law at the University of Michigan and had communicated this intention to Harry B. Hutchins, who was then dean of the Law School. While this initial bequest was modified in Cook's later wills, becoming a much more complex and ambitious gift program, this first version already hints at a recurring theme in all of Cook's gifts to the university, namely his concern to foster the highest quality of teaching and research at the University of Michigan Law School.

As his second act of generosity toward the university, Cook pledged a gift of another kind in 1914—construction of a women's dormitory in memory of his mother, Martha Cook. It was completed in time for the beginning of the 1915–16 academic year at a cost of $260,000. As he would do in his later donations, Cook had made his offer concerning the Martha Cook dormitory to the Board of Regents in the form of an anonymous letter, identifying himself only as an alumnus of the university. More significantly, at the time of the donation Cook had already engaged the prominent New York firm of York & Sawyer to design the building, and the architects were ready with plans and drawings when Harry Hutchins, now

president of the university, read Cook's letter of offer to the regents at their meeting of February 1914.

After the Martha Cook bequest, President Hutchins continued to foster an ongoing relationship with Cook. Dean Bates reports in *A Book of the Law Quadrangle* that not long after the Martha Cook building was finished—"sometime around 1918"—Cook had agreed to fund construction of a freshman dormitory. This is probably the building referred to in a letter dated 1 March 1919 from building contractor Marc Eidlitz & Son in New York to the architects York & Sawyer, stating that: "Our revised estimate for the proposed Quadrangle Building at Ann Arbor, Michigan, in accordance with your latest plans, memorandum, specifications and verbal instruction, is approximately $1,002,300." This letter accompanies an itemized estimate of costs for materials for the proposed building dated 6 March 1919. Evidently full agreement between Cook and the university could not be reached in this case, and the project was dropped, "presumably sometime in the year 1919," according to Dean Bates's recollection.

Dean Henry M. Bates

Dean Bates is not specific as to just when plans for a new Law School began to take shape in the minds of university officials. As noted above, the regents had already been alerted to the need for more suitable quarters for the Law School and its library at their meeting of November 1919. President Hutchins communicated this urgent need to Cook, who immediately indicated his interest in such a project, contingent on presentation of a detailed proposal for his perusal. Cook suggested that Hutchins and a representative of the Law School meet with him in New York to discuss the plan, which included a proposal for an endowment to support legal research and graduate work. Hutchins subsequently grew too ill to make the trip, and Dean Bates took on the matter in his stead. In the spring of 1920 he carried a carefully prepared memorandum spelling out plans for the Law School's needs to New York, and after several days' discussion and revision, Cook gave his agreement to the project.

Correspondence indicates that Cook was still altering his provision for the quadrangle complex in fundamental ways

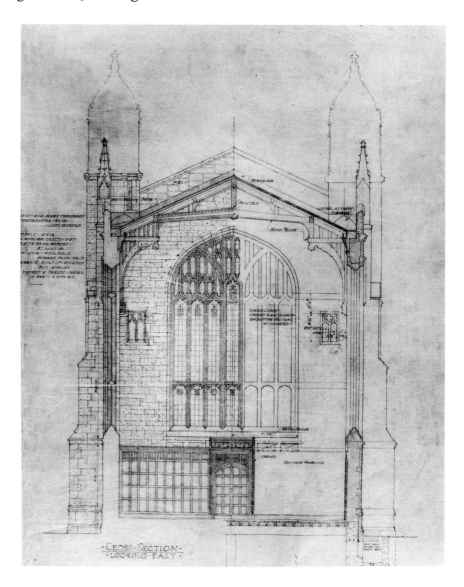

·CROSS·SECTION·
·LOOKING·EAST·

Original York & Sawyer drawing, interior of Dining Hall, cross-section, looking east

well after his meeting in New York with Bates in 1920. Writing to York & Sawyer on 25 July 1921, he told them: "I have concluded to have the new dormitory at Ann Arbor for law students, instead of literary students, and shall call it 'The Lawyers Club,' and all profits will be used for legal research. I don't think this will change the plans for the building. . . ." This important proviso for the Lawyers Club, then, was added only two months before Cook's offer of a donation was first presented to the regents.

What all of this means is that the scanty and laconic record

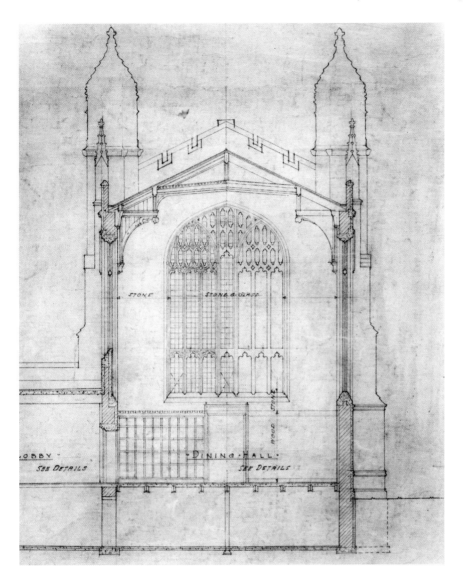

Original York & Sawyer drawing, west facade of Dining Hall

of the regents' *Proceedings* from 1919 to 1921 hardly conveys the level of activity that must already have been under way in these years to provide for more spacious and functional quarters for the Law School. In the memorandum of 1920, agreement had already been reached to construct a quadrangular complex that would include both dormitory buildings and a new library. Plans for the first building—the Lawyers Club—were not officially presented to the regents until April 1922. Nevertheless, a letter of 24 December 1921 from Dean Bates to the architects York & Sawyer concerns the future Legal Research Building

("the Law School Building") and indicates that, from the beginning, Cook and the university projected construction of a four-building quadrangular complex. The letter contains Dean Bates's proposal for a configuration of the buildings that was never seriously considered:

> I am sending herewith some data and other information relating to the needs of the Law School Building, which Mr. Cook is proposing to build for the University of Michigan. I understand that you want this matter not for drawing plans of the Law School Building at the present time, but simply to get an idea of its mass and the possible forms which might be given to it, so as to enable you more intelligently to plan the Lawyers' Club Building. . . .
>
> We have talked only of grouping the four proposed buildings around the outside of the available land, giving the quadrangular effect. This is perhaps the best plan, but it seems to me important that we consider every other reasonable possibility. How would it do, from the architectural point of view, to put the dormitories around the outside of the land and the Law School Building, which after all is the central feature, in the center of the plot, so far as the east and west line is concerned, but pretty well back toward the South? There would be a certain logic and certain propriety in this arrangement. It would, beside, give to the Law School greatest quiet, for it would then be far away from the streets.

At the board meeting of 25 April 1922 Cook's proposed donation of a dormitory and club building with sleeping and study rooms for 150 law students and dining accommodations for 300 was officially presented to the regents. Cook continued to request anonymity. The project was presented in his stead by President Emeritus Hutchins, Dean Bates, Professor John F. Shepard (supervisor of plans), and architect Edward York of the firm of York & Sawyer. Cook's own wishes and stipulations were, nevertheless, unequivocally represented at the meeting in the form of a lengthy letter to the regents laying out the terms of his donation. In it he proposes to construct "a law students' combined club and dormitory building" to be known as "The Lawyers' Club," on the two blocks on South University Avenue

between South State Street and Tappan Avenue. The terms of the donation specify what the administrative structure of the Lawyers' Club is to be and the eligibility for membership:

> All members of the Law School are to be eligible to member-ship in the proposed Club, subject to such conditions as the Club authorities may prescribe. All lawyers whether residing in the State or not, and whether previously connnected with the University or not, shall be eligible to membership, sub-ject to being elected by the Governors. All occupants of the building shall be members of the Club and shall pay such annual dues as the Governors may determine, and are to be selected by the Dean of the Law School from the senior class.

Certain parts of the wording of this letter of donation, specifi-cally regarding membership in the Lawyers Club, were sug-gested by President Hutchins in a letter to Cook of 14 Octo-ber 1921.

The most far-reaching provision of Cook's donation was his stipulation that all dues and profits generated by the Lawyers' Club be used exclusively for legal research:

> This legal research work will render possible the study of comparative jurisprudence and legislation, national and state, and also of foreign countries, ancient and modern. Such work should be of use in proposed legislation, and, besides leading to the production of reliable law treatises and studies, would help to systematize law as a science. The European plan of giving leisure time to professors to pursue their studies and produce original works, may well be applied in America to professors of law, who at present are absorbed too exclusively in class-room work. A legal research fund could be used to pay part of their salaries, thus giving them time for original research.
>
> The character of the legal profession depends largely on the character of the law schools. Real lawyers were never needed more than now, and they have grave responsibilities. There never was a time when they had so much power as now. It will be for the lawyers to hold this great republic together, without sacrifice of its democratic institutions.

The *Ann Arbor Times News* for 28 April 1922 announced

Cook's donation under the banner headline, UNIVERSITY GETS BIGGEST GIFT TODAY: *Building to Cost Millions Will Aid in Work of Law School Here Say Faculty Members.* "The board of regents today announced the formal acceptance of the biggest donation ever made to the university." The article goes on to describe the rationale behind the Lawyers' Club: "It is the belief of the donor and of the university authorities and the law faculty that there will be great advantage in law students living together and in at least occasional contact with visiting lawyers who may be members of the Lawyers' Club. The discussing of legal problems which the students engage in under such circumstances are of the highest educational value."

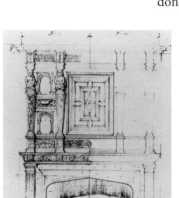

York & Sawyer drawing for fireplace, J. P. Cook Dormitory

Whether the idea to generate a fund for continuing legal research at Michigan was Cook's own or a response to expressed needs of the Law School, there is no question that the subject of legal research at America's leading law schools is one that Cook took up again in his own writings. The same year—1922—in which his donation to the Michigan Law School was made official, Cook published his *Power and Responsibility of the American Bar* (New York: Tudor Press, ca. 1922) and five years later his *American Institutions and Their Preservation* (Norwood, Mass.: Norwood Press, ca. 1927). Cook's references in his letter of donation to international law, to the relationship of American jurisprudence to that of Europe, and the importance of pure research, have echoes in both publications.

According to Henry M. Bates, who was most familiar with the circumstances of Cook's donation, the memorandum of agreement between Cook and the university, signed in the spring of 1920, was incorporated almost word for word into Cook's will providing for the university. Dean Bates singled out the most important aspect of Cook's gift:

> Mr. Cook felt strongly that it was the duty of the State to maintain the Law School on a par with the best law schools of the country. He wished his gift to be used for what he called "top purposes," such as the great expansion of research and graduate work, the payment of exceptionally high salaries to

legal scholars and teachers of outstanding ability, the improvement of the library, and the establishment of fellowships and scholarships. (*A Book of the Law Quadrangle*, 25–26)

The first part of the Law Quadrangle to be completed was the Lawyers' Club residence hall, facing onto South University Avenue, and its adjacent lounge, recreation room, guest rooms, dining hall, and kitchen along South State Street. These buildings were completed and occupied in fall 1924 and formally dedicated on 13 June 1925. In an interview with the *Ann Arbor Times News*, published on 3 June 1925, Dean Bates reiterated the Law School's intentions in bringing together students and professionals in this unique habitation:

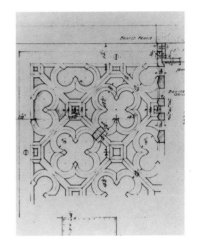

York & Sawyer drawing for bronze grille, entry to "N" house, J. P. Cook Dormitory

> Above all, it is in a social and physical way the ideal that from the association of the students with the men of the actual practice of the profession will come a higher idealism in practice and a better understanding of the men who go out from the law school. . . .
>
> It has been said with some justice that though the legal education given in the better law schools of today is, on the whole, vastly superior to the old type of office instruction, yet there is lacking some of the old personal contacts between the active members of the profession and the legal scholars and the law students.

At a special Board of Regents meeting of 11 January 1929, Cook revealed in a letter his plan to construct for the university a Legal Research Building at a prospective cost of $1,750,000. This beautifully designed and appointed structure would be the focal point of the developing Law Quad group. In the meantime Cook announced to the regents on 26 April 1929 his donation of a second dormitory building to complete the Tappan Avenue side of the Quadrangle. Called the John P. Cook Building in memory of his father, the building was completed in 1930.

In the summer of 1931 the William W. Cook Legal Research Building was finished. The last segment of the Quadrangle to be constructed was Hutchins Hall, named after former Presi-

dent Harry Hutchins and completed in fall 1933. This enormous building was constructed to accommodate the administrative and professorial offices, the classrooms, lecture and seminar rooms, the court room, and the editorial offices of the *Michigan Law Review*.

William Cook's insistence on secrecy—his anonymity as donor of the Lawyers Club was preserved up until the plaque with his name was affixed to the wall of the completed building—and his declining to visit the finished quadrangle suggest a modest and private man with a somewhat detached attitude toward the immensely costly project he had underwritten. In fact, the surviving correspondence from the years of planning and construction of the Law Quad presents a very different picture of this successful Law School alum—a picture of a forceful and even opinionated man, generous in the extreme to his alma mater but keeping a sharp eye on every expenditure during the complicated project.

Cook's Involvement with Construction

Cook was closely involved with the realization of the Law Quad at every step, but only certain aspects of the project interested him. In other considerations he showed no interest at all and left it to others to make the decisions. He seems to have had no background in architecture, for example, and left the design of the buildings to his trusted experts, York & Sawyer. A brief reference in a letter of 18 March 1922 from Edward York to Dean Bates reveals what proved to be Cook's most consistent interest where the buildings were concerned—namely, their external appearance.

> I submitted our revised drawings for the Lawyers Club and
> dormitory to Mr. Cook yesterday morning. I explained to
> him the capacity of the plans, but he showed no interest
> [changed in York's handwriting to 'little interest'] in them.
> He was very much pleased, however, with the perspective of
> the exterior and authorized us to go ahead developing the
> drawings far enough to get a reasonably close approximate
> estimate.

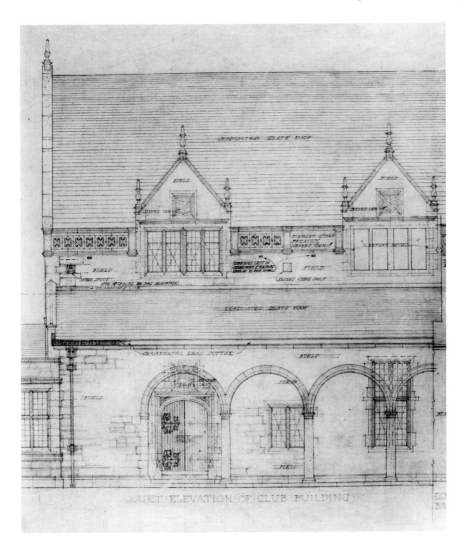

Cook's interest in the exterior of the buildings manifested itself particularly in his concern with the color and appearance of the exterior stonework (to be discussed more fully below) and, when plans for the Legal Research Building were nearing completion, in his somewhat belated expression of a preference for prominent turrets on its corner towers. In this latter instance it is as though Cook were indulging a final whim to impress his individual stamp on this masterpiece. These, too, will be looked at in more detail below.

Other aspects of the building project Cook claimed as his rightful domain. The most important of these was his right to scrutinize and approve all costs and expenditures at every stage

Original York & Sawyer drawing of court elevation, club building

43

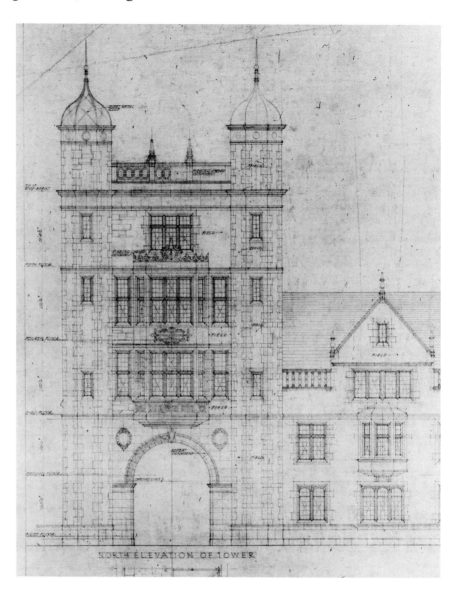

NORTH ELEVATION OF TOWER

Original York & Sawyer drawing of north elevation, tower

"I hope to see that building a masterpiece and monument."

Letter from W. W. Cook to York & Sawyer, 30 September 1922

of the project. It is clear from the voluminous correspondence from this period that Cook wanted only the highest quality materials and construction for the Law Quad buildings but, at the same time, he was vigilant in saving costs wherever possible. An early example of this was Cook's idea about the letting of the contracts for the Lawyers Club, raised in a letter of 13 November 1922 to York & Sawyer and taken up again in a series of letters of January 1923. Cook's letter of 13 November 1922 to Edward York reads: "What do you think of the idea of letting

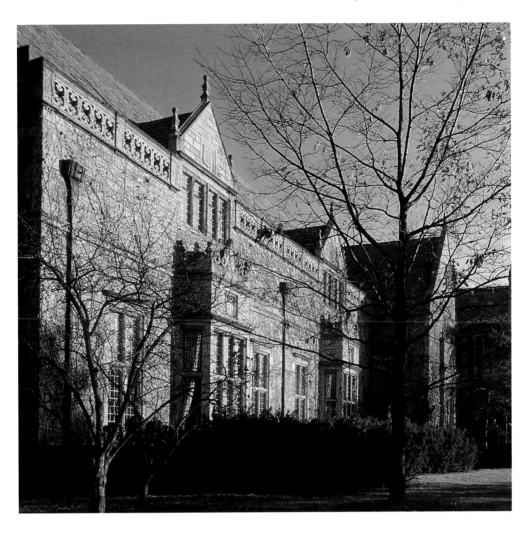

the two contracts for excavating and foundations in advance of and separate from the general contract? Perhaps this might enable us to put off the letting of the general contract for some time after February and still have the building ready for occupancy October 1, 1923."

Cook's motive in suggesting this unconventional procedure evidently stemmed from his belief that labor costs were bound to drop lower during the winter and that money could be saved by letting the general contract as late as possible, while still commencing immediately on the foundation work.

Another issue of cost that prompted a great deal of correspondence among Cook, York & Sawyer, and Dean Bates had to do with the type of decorative exterior stonework that

Stonework of the Lawyers Club west facade in the late autumn sun

45

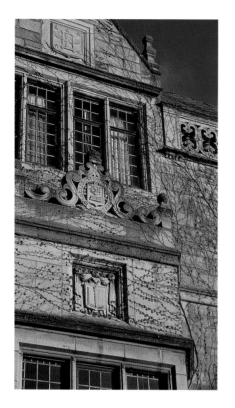

would be selected for the buildings. In fact, the exterior stonework, which involved hand-cut moldings of limestone around windows and doorways, contrasting with the colored stone of the exterior walls, was the single most costly item in the construction of the buildings, outside of the stone making up the fabric of the walls themselves. In the case of the Lawyers Club, out of a total estimate for materials of $1,002,300, the masonry of the walls was estimated to cost $150,558 and the exterior stonework $143,567. In deciding just how magnificent this stonework should be, Cook seems to have been pulled between his desire to make this outer aspect of the buildings truly special and his desire to hold down costs. An exchange of letters on the subject with architects York & Sawyer shows something of Cook's ambivalence. 30 September 1922, Cook to York & Sawyer:

> I have duly received your favor of the 27th inst. and trust that Fuller's estimate will not render inadvisable the elaborations you are making in the designs. I hope to see that building [the Lawyers Club] a masterpiece and monument and should be very sorry indeed if your artistic ideas had to be cut down.

A letter of 9 October 1922 from Cook to York & Sawyer begins with Cook's grave concerns about costs and the possibility of cutting them. He inquires about the possibility of changing from an all cut-stone exterior to one of brick with stone trimming (as in the Martha Cook Building). He says that Dean Bates had suggested this to him as one way of trimming costs. But then Cook concludes with this proviso:

> I do not think it would do now to change the general design of the building. It has been published too widely and the University has spent too much money for the site, and the students and faculty have based too many high hopes on the whole matter to admit of any radical change.

In a letter of 30 September 1922 Dean Bates had suggested to Edward York the idea of moving to a less expensive form of building material:

> I should be perfectly satisfied myself to have brick walls rather than stone, and thereby effect a big savings. It has also been suggested to me that which is known as Kelleys Island stone is a material which is obtained at much less than the cost of most building stone in this part of the country. As I understand it, it is a grey stone, better adapted to rough work than to smooth surfaces. Personally I would prefer a good brick building with stone trimmings, to a cold grey stone, even at the same price.

York, writing on 21 October 1922 to Dean Bates, does not respond positively to the dean's suggestions. York's use of the term "combination" here refers to what he describes as "an organization which has lately been effected among the dealers in building stone, who have raised the prices enormously."

> I am having my troubles with Mr. Cook regarding excessive costs of his buildings. If I could only get at him, I could probably straighten the matter out, but he is still in Port Chester and doesn't want to see me.
>
> Your suggestion to him (which of course I know was made with the best intentions), that there was a stone combination and that he consider brick, hasn't made it any easier for me. The second estimate for stone work was very much in excess of the first, which with your suggestions, naturally made him suspicious.
>
> This advance is due to the fact that we have made the windows very much wider, which adds a good deal of cut stone, and we have made the exterior much more interesting, because Mr. Cook was afraid it would be too plain—which opinion was justified when we made the larger working drawings.
>
> I hope you will let the incident in regard to the brick drop, as we have ample ways of protecting our clients from combinations such as you feared.

A subsequent letter of 27 October 1922 from Edward York

to Cook, in reply to Cook's inquiries about prices and types of stone reads:

> The seam faced granite has a great variety of color and if the bona fide estimate on this material is attractive enough you could get 'most any selection of color that you wanted. There are no very large surfaces of ashlar, as the walls are pretty much all windows, so a little variation in color would add interest.

Most remarkably, letters between William Cook and the administration of the Law School reveal the extent to which Cook expected to practice oversight of the Lawyers Club and its financial affairs even after construction was completed and the club was in operation.

The Lawyers Club October 14, 1924
 University of Michigan
 Ann Arbor, Michigan

Dear Sirs:

If there are no objections I wish you would have your book-keeper send me each month statements, similar to the ones I receive monthly from the Martha Cook Building, which I enclose. Kindly return them to me. I shall be particularly interested in the details of how you spend your profits, because that involves one of the main purposes of the build-ing. I wish you would also let me know the distribution of the rooms among the three classes; also the number who dine there, and how many from each class and from out-siders and who the latter are.

Yours very truly,
William W. Cook

Cook as Author of the Inscriptions

In the actual construction and decoration of the Law Quad, the aspect that seemed to interest Cook the most was the inscriptions that were to be placed in proximity to the entrances of the buildings. The Lawyers Club was the first to receive its inscriptions. Cook was asked to write the texts by Edward York, who noted in a letter of 4 October 1923 to Cook: "As these buildings are permanent and as time changes ideas, it would be nice to have some inscriptions that would give the original purpose of the building or any sentiment which would signify the spirit and the use for which it was constructed." Cook immediately took up his assignment with great enthusiasm, telling York: "You certainly have given me a beautiful task to write five inscriptions for your wonderful Lawyers Club Building at Ann Arbor. . . ." Cook's various interests seemed to come together in the task of devising these

inscriptions: his interest in history, his high regard for texts and the written word, and a liking for expressing himself in aphorisms.

The care with which he prepared these is clear in the numerous versions and revisions he sent for consideration to York & Sawyer. He first proposed five inscriptions in a letter of 11 October 1923, then revised these on 5 February 1924. Further revisions were proposed in his letter to Edward York of 1 April 1924. The five inscriptions eventually chosen read as follows:

1. Over the entrance from State Street:
 THE CHARACTER OF THE LEGAL PROFESSION DEPENDS ON THE CHARACTER OF THE LAW SCHOOLS. THE CHARACTER OF THE LAW SCHOOLS FORECASTS THE FUTURE OF AMERICA.

2. On the west tower:
 THE SUPREME COURT: PRESERVER OF THE CONSTITUTION; GUARDIAN OF OUR LIBERTIES; GREATEST OF ALL TRIBUNALS

3. Over the east arch:
 UPON THE BAR DEPENDS THE CONTINUITY OF CONSTITUTIONAL GOVERNMENT AND THE PERPETUITY OF THE REPUBLIC ITSELF.

4. Above the entrance into the Dining Hall from the Quadrangle:
 FREE INSTITUTIONS, PERSONAL LIBERTY

5. Above the east tower entrance on the Quadrangle side:
 THE CONSTITUTION: STEEL FRAME OF THE NATIONAL FABRIC; WITHOUT IT THE STRUCTURE WOULD FALL INTO RUINS.

Cook derived inscriptions number 1 and number 5 from the text of his letter of donation of 25 April 1922 pledging to the regents the construction of the Law Quadrangle. Inscription number 3 is a line from his book *Power and Responsibility of the American Bar*.

The degree to which the problem of the inscriptions occupied Cook's thoughts is evident in a letter he wrote to York, dated 7 February 1924. In it he informed York that President Harry Hutchins had cautioned him that "possibly the architects are suggesting too many inscriptions." Hutchins advised using only one inscription rather than five. Cook explained his rationale to York in his letter:

I have the greatest confidence in [President Hutchins's] judgment and good taste, and in fact he is a sort of godfather to that building and the Martha Cook Building. I think it likely others have discussed the matter with him, knowing of my respect for him and his opinion.

Personally I would like to have the inscriptions, because they show the motives causing this building and will be a continual and perpetual reminder of the obligations and duty of the law students and law schools. Of course, we don't wish to do anything in bad taste but my recollection is that the Harkness Tower has inscriptions all over the building and all sorts of queer things and I never heard anyone criticize them. Perhaps I am misinformed as to that. Do you know? . . .

In a response of 9 February 1924 York reassured Cook that the inscriptions were, indeed, appropriate and desirable.

As you know, inscriptions have formed an important element in architectural designs since the earliest times. All through the Egyptian, Greek and Roman work, the inscriptions lend the greatest interest to the buildings which they adorn, not only for their decorative quality but for the information they give as to the purpose of the buildings and the character of the people who erected them. . . . Gamble Rogers, architect of the Harkness Memorial group at Yale, tells me that there are inscriptions, he believes, over every entrance to the quadrangle and that the buildings bear in all some forty-nine inscriptions upon their exterior.

Among our own buildings, the Bowery Savings Bank, the Brooklyn Trust Company and the Federal Reserve Bank of New York have inscriptions in their interior and the Greenwich Savings Bank has them both inside and upon the attics over the two end porticos.

This last statement suggests that the idea of including inscriptions in the design of the Law Quadrangle buildings originated with the architectural firm. This seems especially so since it was York who asked Cook to supply the inscriptions.

If Cook left the detailed plans for the Lawyers Club and the Cook dormitory to others, when working drawings for the

Legal Research Building were in preparation six years later, he thrust himself vigorously into the planning. Indeed, he seems to have considered the prescribing of an efficient interior arrangement of the library to be his personal responsibility. He viewed the Legal Research Building as the crown jewel of the Law Quadrangle, and it is clear that he harbored a very proprietary feeling for the building as the future center of legal research at Michigan.

Planning of the Legal Research Building:
Cook vs. the Faculty

In contrast to the other building designs of the Law Quad, which had gone relatively smoothly, the planning of the interior arrangements of the Legal Research Building became a battleground, in large part because Cook took immovable positions on matters about which he considered himself to be an authority. To begin with, he had ordered the architects to start drawing up plans without consulting the Law School faculty. To the faculty this suggested a disdain for the input of those whose needs the building was meant to fulfill and caused many of them to have serious trepidations about the entire process. Dean Bates was particularly alarmed about the turn of events and conveyed his unhappiness in private communications, though not in public. When work had first begun on the Lawyers Club, Cook and Bates had enjoyed reasonably good relations, but by the time work reached the Legal Research Building they were open foes. Eventually Cook was in opposition to almost everyone at the University. His letters show him becoming peevish and dictatorial. As he declared in one letter: "I know nothing about architecture but have had more experience in legal research than any of them." Cook's concerns took in everything from the location of bookcases, student work tables, and study carrels, to the question of a multistory "extension" that was already under discussion before the Legal Research Building was built.

The tenure of President Clarence Little, November 1925 through January 1929, corresponded exactly to the years when the Legal Research Building was under design. His role in the project and in the carrying out of Cook's donation are crucial to the story of the building, and it was Little's conflicts with Cook

that were largely responsible for his premature resignation after only three years in office. (The history of Little's tenure and its conflicts is contained in Daniel K. Van Eyck, "President Clarence Cook Little and the University of Michigan," unpublished Ph.D. diss., University of Michigan, 1965.) Little first went to visit Cook in New York shortly after his induction as president in 1925. The regents and university officials were delighted to learn that Cook and their new president seemed congenial and that the president gave promise of having considerable influence over Cook. Early in the project, in a letter of 9 September 1926 from Cook to York & Sawyer, Cook approved of some design changes suggested to him by President Little that would involve reversing the functions of two of the floors of Legal Research:

President Clarence Little

> President Little was with me on Tuesday and in talking with me about the proposed law library building at Ann Arbor I explained somewhat our present idea and he suggested that what we have on the second floor might better be put on the first floor, and what we have on the first floor be put on the second floor. He says this will give more quiet to the research workers and professors who would be using the small rooms and at the same time would render the working desks very accessible to the students by the latter being on the first floor, and more important still would avoid the noise of the students going through the first floor in order to get to the second floor where we had located the benches. I think he is right about it and so I wish you would make that change in the next plan.

Edward York, however, pointed out the problems with the new scheme (16 September 1926; York to Cook):

> With regard to your letter of the 9th setting forth your talk with President Little, I would say that we all feel here that this suggestion of shifting floors would be far from satisfactory. In the first place we have to have some sort of circulation, and it should be in the low ground story; the reading room we feel should be up out of the hurly-burly, where it

will be perfectly quiet. Most of the research rooms, in any case, would be at the back of the building, and due to their position, perfectly quiet.

By 24 February 1927, however, a letter from Cook to York & Sawyer indicates an apparent misunderstanding among Cook, Little, and the architects about the exterior appearance of the new building, at what was then an advanced date in the planning:

> President Little was in New York . . . and I requested him to come to Port Chester because I wanted to talk with him about the situation generally at Ann Arbor. His description of the proposed Library Building does not suit me at all. As I told Mr. York last summer, I don't want a tall building of two stories. Domes are magnificent but expensive and unnecessary in that kind of a building. I won't have it.
>
> The arch should be low as on the outside of the dining room building, but no dome inside as in that building. A building of two stories may be enlarged in the plan to cover more ground space (if more room is needed) but must be low and the windows go to the top. The first as well as the second floors should be given over almost entirely to books and study places. The windows on the first story should be larger and higher. All this I explained to Mr. York last summer but apparently without effect. The plan I saw last summer looked like a barn. Kindly count me in on this deal. If three stories are needed all right, but no magnificent arch.

York's reply to Cook, also dated 24 February 1927, indicates the confusions among the principal parties:

> P.S. Just as I had signed the above letter, yours of even date was handed to me. I cannot imagine what President Little said, as the plans that we showed him were worked out along the lines we agreed upon at our last conference, and I hope you won't condemn them on his description without going over them with me. I want to follow your suggestions and if that has not been done in these revised plans, I will have to make another try.

In July 1928 Cook wrote the draft of a six-page letter to Edward York in which it is easy to see his growing irritation and his sense that his directions are either not being understood or not heeded. In fact, Cook never sent this rather testy letter, rewriting it instead, condensing it, and making it more businesslike in tone, resulting in the version of 16 November 1928. In this document, Cook was still dealing with issues of seating, research rooms, etc., but his main preoccupation now was the proposed multistory extension to Legal Research. In this and other letters Cook was adamant that the extension proposed for the south side of the building should not be built until several years later. His arguments were that the extension was not needed at that time, and since its purpose was to provide for more seats, more research cubicles, and more books, it would be better to wait until it was clear how much more capacity would be needed for each of those items rather than trying to plan for an unknown number. Cook was unconcerned that the entire Law School faculty, and in particular Dean Bates, opposed him concerning this and the other issues involving the internal arrangements of the library. Bates considered that Cook was becoming much more authoritarian, to the point that the dean viewed Cook's attentions as chronic interference. Bates wrote to Regent Sawyer on 19 November 1924 that "Cook's manner is arrogant and he is, of course, wholly ignorant of local conditions." Cook, for his part, felt that he could trust no one outside of Secretary Smith, Regent Sawyer, and President Emeritus Hutchins.

Even before work had begun on the Legal Research Building, serious disagreements began to emerge. In his draft letter of July 1928 Cook referred to "Messrs. Bates, Little, and Coffey," as the *bloc* and called them cantankerous. (Coffey, Law School librarian, was later to serve for many years as Director of the Law Library.) President Little found Cook implacable and entirely impossible to work with. At one point in 1927 Cook had threatened to pull out of the building project altogether, citing the "serious differences between Bates and Little and myself as to the proposed new library building." Little took this threat seriously and on 28 November 1928 informed the board of regents that he recommended they go ahead with construction plans

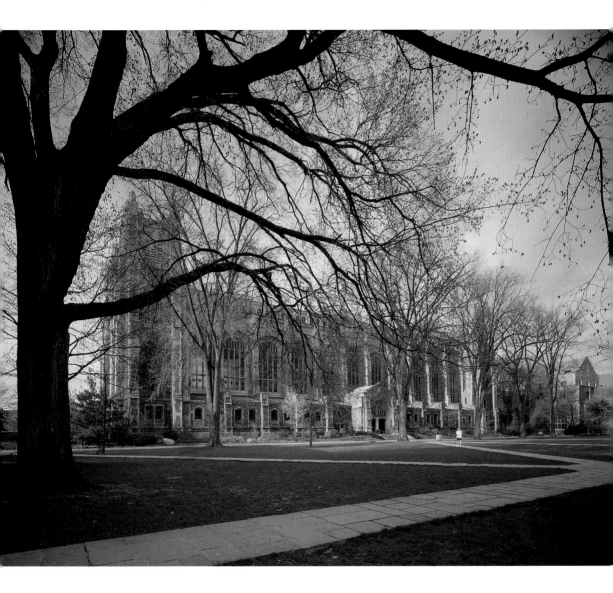

Legal Research building, seen from the northeast, indicates that York & Sawyer successfully addressed Cook's persistent concern that the building not present a "stubby appearance."

"If three stories are needed, all right, but no magnificent arch."

Letter from W. W. Cook to York & Sawyer, 24 February 1927

for the Law School and detach the university completely from further negotiations with Cook. He further advised that the university should immediately approach the Michigan Legislature for the funds to construct the projected classroom building rather than placing future expectations in Cook's will, which had promised an additional donation to the Law School in the amount of $18 million.

The president's letter, proposing a break with Cook, had the effect of solidifying a growing opposition to his administration, which was widely viewed as inept. "I wish that letter had not been written," Regent James Murfin wrote to the president. Even though many of the university officials had to agree

with Little about Cook's demanding personality, they were not ready to snub his support for the Law School. In a series of meetings at the end of 1928 the regents forced a resignation from President Little, citing his lack of diplomacy and unwillingness to compromise, which they maintained were an offense both to donors and to the state legislature in Lansing. Little submitted his resignation in January 1929.

Interestingly, for his part, Cook got most of what he wanted on the two floors of the Legal Research Building.

When the designs for the Legal Research Building were almost complete, however, Cook rather suddenly expressed unhappiness with the external profile of the building and requested that York & Sawyer add prominent pinnacles to the four corners of the building, similar to those on the Lawyers Club Building (Cook alternately referred to these as minarets, pillars, pinnacles, or turrets). When the architects expressed their reservations about such a feature, Cook wrote back to York:

> Yes, I realize that the Legal Research building will be the central building but I think that is the very reason why it should not present a stubby appearance. At any rate kindly raise the corners 20 or 30 or 40 feet and let us see how the whole building will look.

Ten days later (1 May 1928) Cook was still unhappy with the design and requested more fundamental changes:

> I would ask that you sketch a lower building with two rows of windows similar in appearance (the upper perhaps a little greater in height than the lower) with a tower in the centre (to break the factory effect) and towers at the four corners, similar altogether to the Lawyers Club Building—a masterpiece. Then the two buildings will correspond. This building is being built for five hundred years. . . . I don't believe I shall ever like the present design. It looks for all the world like a cathedral.

By August, Cook was telling York not to worry about the time required to incorporate new features into the design in a letter of 17 August 1928:

Take all the time you wish. . . .The fact is I wish that central building [the Legal Research Building] to be an outstanding monument of American architecture, besides being a credit to your firm and the University of Michigan. I want it done right, irrespective of time. I assume that you are calling in the combined genius of all of your firm.

In a letter of 5 December 1928 Cook was still urging addition of the pinnacles:

And even if the pinnacles are put on they can be removed if subsequently the general verdict is against them. A little sparkle and fancy will do no harm to that ponderous building.

Cook's final word on the subject appears in a letter of 13 December 1928:

P.S. I still think you can improve the pinnacles. You gifted architects are too conservative by far. Hang the banner on the outer wall; let loose your genius; put a little more life into the picture. Make it as attractive as the Lawyers Club Building. You can do it.

Expressing his familiar concerns about expenses to York's partner, Philip Sawyer, Cook also wrote: "And no gargoyles, lions rampant and such like gewgaws. Bad taste and useless expense."

When Cook died on 4 June 1930, the Law Quadrangle was only half completed. The *Ann Arbor Daily News* recognized his importance to the university in a long obituary, followed by an unsigned article of more personal nature entitled "William Wilson Cook, Real Michigan Friend." This article recounts an anecdote about Cook's insistent attachment to privacy:

Mr. Cook had been charged with eccentricity. Not once had he seen the beautiful building that his generosity made possible on South University Ave. Not once, that is, officially, though it has been persistently rumored that he paid a surreptitious visit once upon a time. The story is that his sentimentality as an alumnus was responsible for his remaining away . . . while he entertained a strong affection for alma

Facing page:
Northwest tower,
Legal Research Building

"A little sparkle and fancy will do no harm to that ponderous building."
Letter from W. W. Cook to York
& Sawyer, 5 December 1928

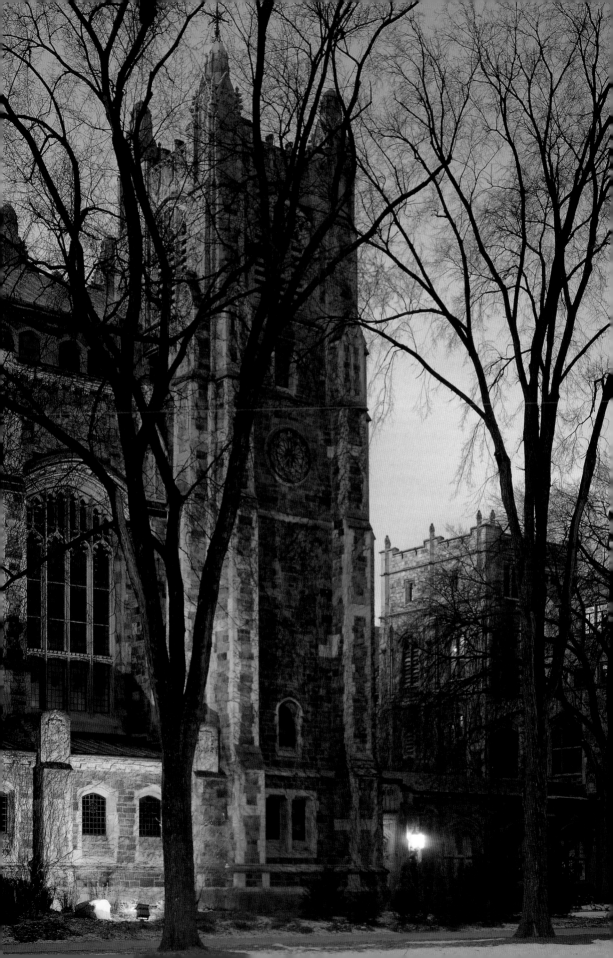

mater and was eager for its progress and expansion, he could not bring himself to look upon the changing skyline. That may be eccentricity, or evidence of human weakness and conflicting emotions.

Years later, at a luncheon with a group of faculty in 1959, Cook's niece, Florentine Cook Heath, confirmed that from 1920 on an active case of tuberculosis precluded her uncle's traveling to Ann Arbor. The *Daily News* article continues:

> That the manner of Mr. Cook's giving caused some complications cannot be denied. He was precise about certain restrictions. There were strings to his gifts. One of the difficulties that led eventually to President Little's resignation revolved about acceptance of those gifts with strings.

The Oversight of Dean Henry M. Bates

In contrast to Cook's sweeping role, the kinds of decisions exercised by the Law School and its administrators were of a more work-a-day variety, but they were made, nevertheless, with just as much concern and anxiety. Unquestionably the single individual within the Law School who took on the majority of responsibility for husbanding the building project to completion was the dean, Henry M. Bates. Bates was dean throughout the period of construction of the Law Quadrangle, which spanned the university presidencies of Harry Hutchins, Marion Burton, Clarence Little, and Alexander Ruthven. Bates accompanied President Hutchins to New York for their meeting with Cook in 1920 to negotiate and finalize the document of donation. When the terms were settled and the gift assured, President Hutchins and his successor, Marion Burton, left the day-to-day management of the project to Dean Bates. And manage it he did. The correspondence indicates that a large proportion of Bates's deanship between the years 1920 and 1933 must have been consumed with the construction project. He traveled back and forth to meet with Cook in New York and Port Chester and to discuss details of the plans with Edward York of York & Sawyer. Sometimes he was accompanying Presidents Hutchins,

Burton, or Little on these trips, but more often he traveled at his own initiative. Bates was familiar with the details of the evolving plans in a way that no other university official was. During the planning stages Bates visited law schools and undergraduate institutions on the East Coast to gather information about dormitory design and living. Most of all he made it his concern to anticipate every smallest need in the living, dining, and educational activities of the future Law School students and to accommodate these needs in the design of the Lawyers Club and John P. Cook Building.

In response to a request from Bates, Regent Matthew Luce of Harvard sent the dean some descriptive material and a list of specifications concerning Harvard's freshman dormitory rooms and dining facilities in October 1921, when planning for the Lawyers Club was just under way. Judging by the number of visits and inquiries made over the next few years, Harvard was looked upon as the prime model for many aspects of the preeminent Law School of the Midwest at Ann Arbor, though a number of other universities and law schools were also studied.

In June 1924, when the Lawyers Club was nearing completion and the Law School Building was already in the planning stages, Bates offered to accompany the architects to Boston and Philadelphia to examine the facilities of Harvard, the University of Pennsylvania, and Bryn Mawr College. These learning trips, along with his personal knowledge of students' needs, made Dean Bates unusually sensitive to those details in the Lawyers Club and John P. Cook Building that would add to the comfort and efficiency of everyday living and to the encouragement of study. The details of these living arrangements were the continuing subject of refinement in countless letters between the dean and Edward York. In a letter of 19 May 1922 Dean Bates wrote:

> I do feel that the general layout of the dormitory scheme is good. My only question is as to the three-suite rooms. . . . Some men are very emphatic that there should not be more than two students in a suite, but, on the whole, I am inclined to think that there are enough people who take the other view to justify us in assuming that a corresponding number

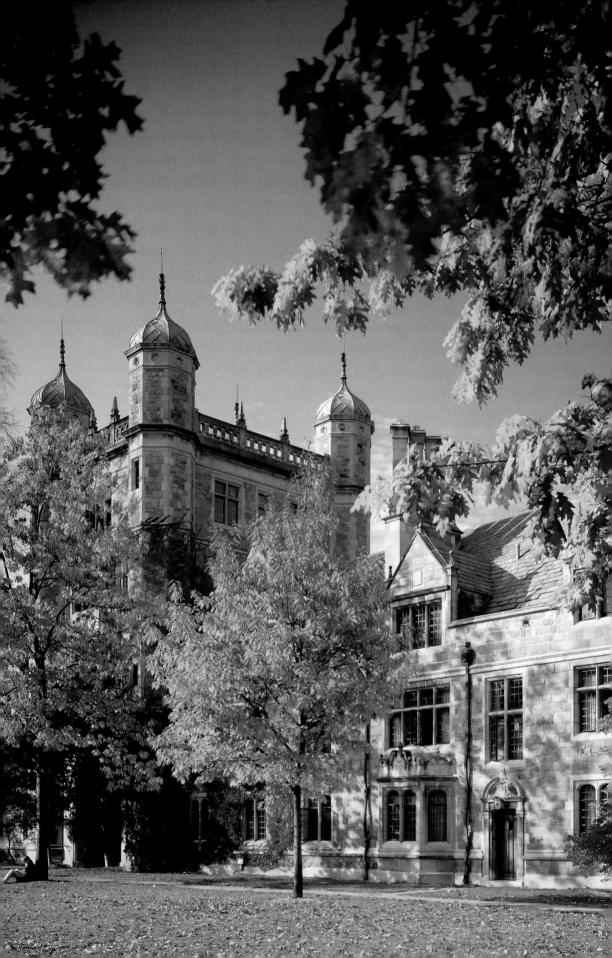

of students will take it and will fill the three-suite rooms. I note that you say you will send larger scale drawings of typical suites, with furniture, plumbing, etc., later.

Other letters from Bates to York continue this concern with the planning of details:

> I do not think there need be any concern about any of the suggestions except the closets. I really feel that they are all small and some of them are certainly too small. The average student will certainly want to hang at least half a dozen coats in his closet, especially if overcoats be included. . . .

His sense of responsibility for a successful result is clear:

> I feel very anxious about the kitchen and serving arrangements. It is notorious that University students grumble about the board furnished them in commons such as we propose. We want, therefore, to be in a good position to do the best possible in this matter and unless the kitchen and serving rooms are light and well arranged, it will be impossible under the conditions prevailing in Ann Arbor, to get suitable help.

In all matters, whether details of furnishings or the exterior stonework, on questions of costs Bates showed a vigilance equal to Cook's own:

> I am sorry about the cost [Bates wrote to York on 27 September 1922]. I feel strongly that it would be possible to make the buildings just as beautiful and serviceable and cut out expense by utilizing some of the materials which can be had here in the Middle West. They are as good as anything that the world has known, perhaps, and not so expensive as materials brought from a long distance. Also, I am satisfied from having looked into two or three actual cases that the New York house which Mr. Cook favors for furniture, furnishings and the like, charges very much more than need be paid for precisely the same things. Can we not cut down by cutting out some items of this sort?

Bates was assisted in his evaluation of comparable dormitory

arrangements elsewhere by Professor John F. Shepard, Supervisor of Plans for the Lawyers Club and the John P. Cook Dormitory. He conducted many of the off-site inspections at campuses such as Harvard and Bryn Mawr. One of the issues being considered was whether heat should be installed in the student bedrooms of the Lawyers Club and Cook dormitories. York's reply to Shepard on this question indicates a hardier time than our own:

> We have gone into this problem very extensively and have noted its solution in other Universities. As a matter of fact, we are unable to find any examples. . . . At Princeton we took particular pains to obtain a personal opinion on this matter from the students and it was universally their opinion that bedroom heat is not needed.

A specific alteration to the plans for the Lawyers Club that Bates and President Marion Burton suggested was the addition of the faculty dining room. A letter of 12 December 1922 from Edward York to Cook indicates that such a dining room could be accommodated within the plans.

> When President Burton and Dean Bates were in New York some three weeks ago, they suggested that it would be a very nice idea if we could embody in the Lawyers' Club a dining room that would seat twenty or so, where the law faculty could have their luncheons and where they could entertain any distinguished guest who might be staying at the Club or delivering a course of lectures. This room could also be used for guests of the Club if they should not care to sit with the three hundred students in the big dining room.
>
> We can rearrange the plans slightly so this works in very satisfactorily. . . .

Dean Bates also made known his views in regard to a monument of sculpture that had been suggested for incorporation into the Quadrangle design. His may not have been the only voice of protest, since the sculpture was never erected:

> I reiterate that I have great admiration for Judge Cooley; and Mr. Cook, as you know, very justly regards him with great

gratitude, as well as admiration, and nothing should be said which could give offense. But is it not practicable, if you agree with my views, to select for the center of our quadrangle some design susceptible of greater beauty than a statue of Judge Cooley?

Cook, in his turn, suggested the treatment of the center of the Quadrangle as a grass-covered commons, in a letter to Philip Sawyer of 4 June 1929. Nevertheless, it is difficult to imagine that York & Sawyer were unfamiliar with this tradition of the green in the English university quadrangle, since it was such quadrangles that they had used as the models for their complex at Ann Arbor. Cook's letter to Sawyer read:

> It has been highly recommended to me that I follow the Oxford plan (now centuries old) to have the large space between the Legal Research Building and The Lawyers Club a plain solid grass plot or lawn and to have no walks through it, the walks to be on the outside border. I rather like the idea. If you are not familiar with it I wish you would inquire into it a little while you are in England. It would be unique and striking and in good taste. It would not hurt the young men to walk a few steps. I don't know what kind of border is used to shut out trespassers, i.e. the lazy ones.

In addition to his varied responsibilities in regard to the Lawyers Club and the John P. Cook constructions, Dean Bates's most critical concern, in his eyes, was for the planning and realization of the Law School Building—the future Legal Research Building. In writing to York about the floors for the dormitory of the Lawyers Club, he said:

> Of course, it makes no difference to me whether the construction is steel or reinforced concrete, except that the object is to save as much money as possible for the important buildings to come later; and I am exceedingly anxious that the Law School building should not be postponed one second longer than is necessary. That is by all means our great, outstanding primary and important need.

As early as October 1922, when work on the Lawyers Club

had just begun, Dean Bates was becoming anxious about whether the Law School Building would eventually materialize. He expressed his worries in a long, confidential letter to Edward York in which he suggested that the Cook project might actually stand in the way of a timely completion of the main Law School Building. Bates's concern was that the Cook project might take years to complete and that the Law School would, in the meantime, lose a likely opportunity to obtain funds for the Legal Research Building from the state legislature:

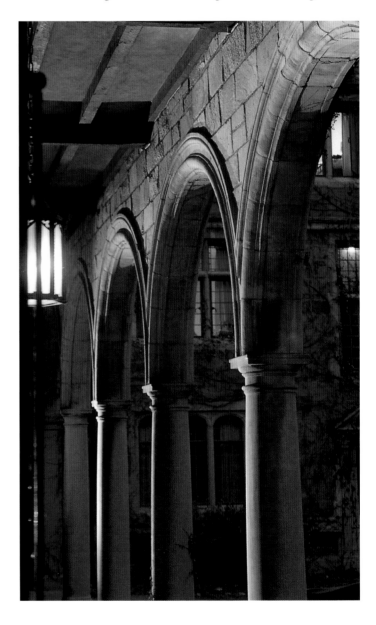

Of course we prefer the Cook plan, but even at the best there will be a postponement of the getting of our Law School Building (which is by long odds the most important thing for us)—a postponement which may last for years. If the high building cost defers the putting up of the first building, the Law School Building will be just that much later.

You will see that it is a very serious matter for us. If Mr. Cook's project, especially as to the Law School Building, is to be long delayed it would be better for us to forego the dormitories altogether and go at the State for this Law School Bulding, with the hope that we could get it started within the next year. . . .

The vital thing for us is the Law School Building. I would rather have it than five hundred dormitory buildings, though the dormitories will be a great help to us and I am very anxious for them.

Dean Bates made no public mention of his belief that the university might do better by approaching the state legislature for building funds. But three years later, in the spring of 1925, Bates was again having serious misgivings about the project, this time prompted by what he saw as Cook's capricious and inexplicable behavior, magnified by his fits of pique over imagined slights. This time Bates expressed his concerns to the regents. His issues were precisely those that would be raised in turn by President Clarence Little, namely that there must be limits on what the University would tolerate even from a highly moneyed donor if the school was to retain its values and its good name.

Nothing resulted from Bates's alarm, but repeated tensions were aroused between Cook and individual representatives of the university through the duration of work on the Legal Research Building. The fact that the construction of this complex building was able to transcend the disagreements over its design and to achieve a result that was largely agreeable to all may be attributed in great part to the diplomacy and flexibility of the architects, York & Sawyer, who maintained the utmost professionalism and good working relations with all the parties involved. The story of their role in the realization of the Law Quadrangle is told in the next chapter.

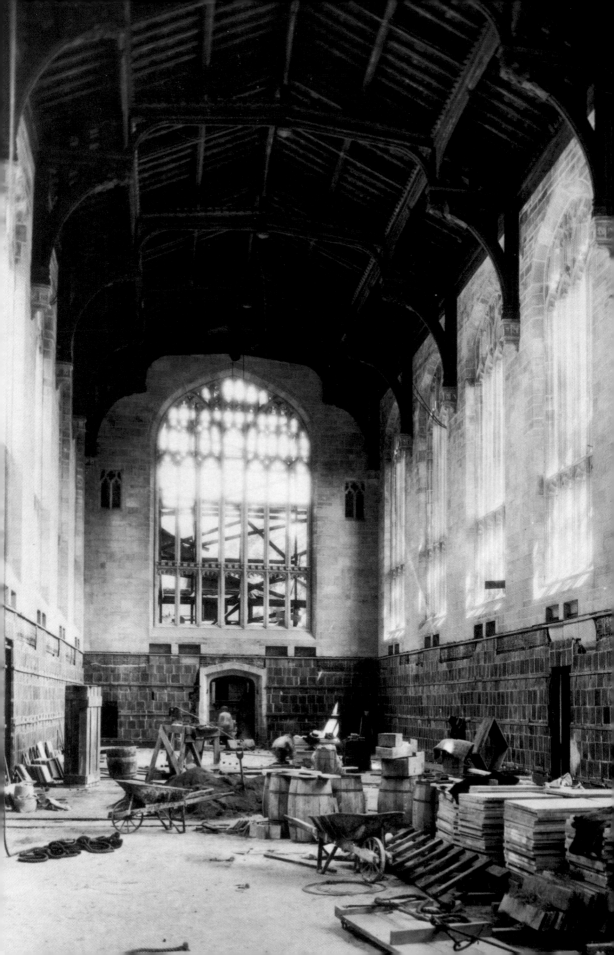

York & Sawyer and the Building of the Law Quadrangle

Historical References in American Campus Architecture

In enumerating the questions we would like to answer about the Law Quad, we have already mentioned a most important one—the question of who was responsible for choosing the striking Gothic revival style in which the buildings are built and who envisioned the quadrangle arrangement in which they are grouped. There is little direct evidence on which to decide these points, since even the earliest letters between Cook, President Hutchins, and the architects make no mention of the style of the prospective Law School. Nevertheless, the indirect evidence strongly points to the architectural firm of York & Sawyer as the party responsible for selecting the Gothic style and determining the appearance of the Quadrangle as it looks today.

The only written reference to the choice of the style appears in a letter of 7 January 1922 from architect Edward York to Dean Bates:

> The reason we have adopted the Gothic style of architecture is because it allows of lots more window area, without sacrificing the architecture. There is no reason why your building should not be well lighted. We have a general feeling here that it makes no difference how beautiful a building may be, if it is not well adapted for its use, it is a failure.

The dean's reply indicated a complete willingness to leave the matter in the hands of York & Sawyer, with no strong opinions of his own on the subject:

> You will find no disagreement here with your feelings. . . .

Facing page:
*Interior, Lawyers Club
Dining Hall under
construction, 8 August 1924*

I do prefer the Gothic style of architecture to any other, but I have seen buildings designed by leading men, East and West, in which some of the rooms were slighted in regard to light. . . . I have the greatest confidence that you are going to produce the best possible results for us.

In addition to the brief reference by Edward York above, there is evidence that the preference for a quadrangular building complex goes far back in the history of the project, indeed, to a time before the Law School donation itself was contemplated and when Cook was discussing with the university the construction of a freshman dormitory. In *A Book of the Law Quadrangle* Dean Bates recorded his recollection that, "In the latter part of President Hutchins's administration (perhaps about the year 1918), Mr. Cook had tentatively agreed to give the money for the erection of a dormitory for freshman students. . . . There were some difficulties in arriving at a full agreement in relation to this dormitory and its administration, and the plan was dropped—presumably sometime in the year 1919." (p. 23)

Nevertheless, the letter of 1 March 1919 from Marc Eidlitz & Son to York & Sawyer, referred to in chapter 2, indicates that this dormitory plan—eventually abandoned—was already conceived as a quadrangle. This is confirmed in a letter from York to Dean Bates of 1 March 1922 where, in referring to the Lawyers Club dormitories, York says, "We are assuming that the arrangements and sizes of the rooms of the dormitories, as shown and approved in the plans for the freshmen's quadrangle, which was abandoned, are correct."

In other words, the choice of a quadrangular plan was not tied to the function of serving legal education at Michigan as much as it was tied to a collegiate setting per se, where it would have been considered just as appropriate to a complex of freshman dormitories as to the ensemble of more specialized buildings serving the Law School. What is more, the quadrangular plan goes hand in hand with the historic Gothic style in which the buildings are rendered, as we saw in chapter 1, and the two elements—quadrangle and historic style—would certainly have been conceived together.

Facing page:
York's emphasis on the advantages of the Gothic style as to light management is borne out on a sunny morning in the Reading Room

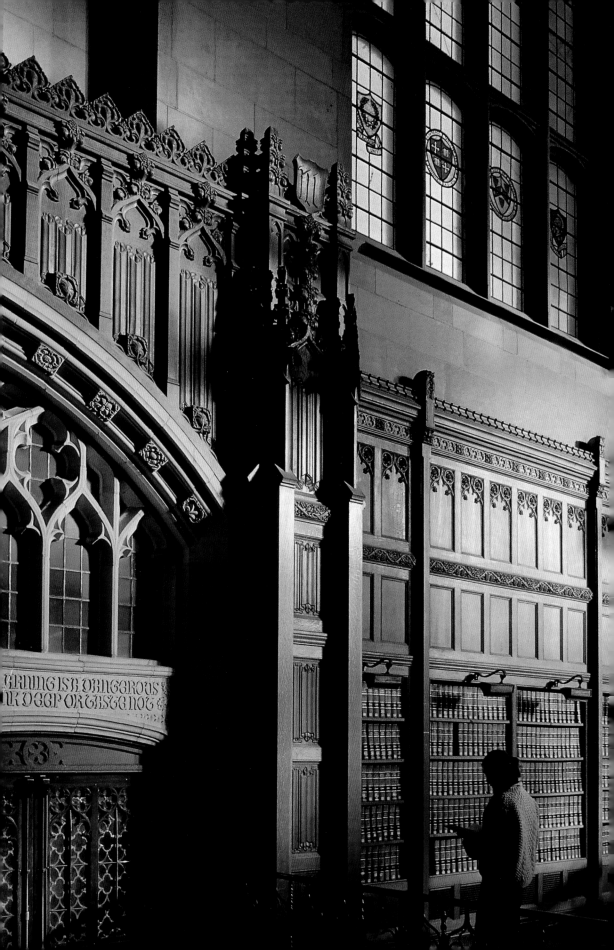

That such a choice would have been made in the early 1920s, first for a dormitory complex and then for the magisterial Law Quadrangle, is not at all surprising. Though the Michigan campus at that time lacked any other buildings in Gothic style—and, in fact, has added none since the Law Quad—Gothic had become the official style for new collegiate construction during the years between 1892 and the mid-1930s, as we described in chapter 1. It seemed singularly appropriate for institutions of higher learning because of its derivation from the preeminent examples of residential collegiate life at the Universities of Oxford and Cambridge in England. Saint Mary's College of Winchester in Oxford (called New College), founded in 1379, was the earliest institution of learning to make use of the quadrangular plan, with collegiate buildings of various functions enclosing a sheltered courtyard on four sides, as noted in chapter 1. Central to its conception was its suitability to an urban environment. Indeed, in France the walled institution of the university came to be referred to as a *cité*, a city within a city where students and faculty could carry on their learning free from the distractions of city life around them.

As with other historic building styles adopted in America, it was the mantle of historical associations and meanings carried by a specific style that led to its adoption by architects and communities. The Gothic style, in favor from the mid-twelfth through the fifteenth centuries, corresponded to the period when the university system was created in Europe. The particular association of Gothic with the beginnings of secular humanism in the great universities of England made it the style *par excellence* for the rising American universities that wished to signal their participation in this great tradition.

Disciples of McKim, Mead, and White

That architects York and Sawyer should have chosen the collegiate Gothic style for the Law Quad commission is likewise not surprising, in light of the firm's interests and its professional output. York & Sawyer were among the several American firms active in the early twentieth century who perpetuated and perfected the architectural ideas of their famous mentors, McKim,

Mead, and White. The latter firm was a leading force in American architecture from the 1880s through the 1930s. Its work and influence were based on a renewed understanding and interpretation of building principles of the past—the ideal classicism of ancient Rome and of Renaissance Italy. York and Sawyer are among the first generation of those who trained with McKim, Mead, and White and who helped to solidify the acceptance of European historical styles as the official language of institutional architecture in this country.

Edward Palmer York studied architecture for two years at

Cornell University, leaving in 1889 to join the firm of McKim, Mead, and White, where he worked primarily under the direction of Stanford White. In his 1927 obituary he was said to have been quiet, retiring, and modest, and above all a scholarly man who read extensively on architecture and its cultural context. His contribution to his firm was described as that of counselor and critic rather than laborious craftsman. In fact, his partner, Philip Sawyer, once wrote laughingly that York never made any drawings.

Sawyer, on the other hand, was a well-schooled draftsman who drew constantly. He obtained a knowledge of engineering with the United States Geological Survey in New Mexico and entered McKim, Mead, and White in 1891. Almost immediately, in 1892, he took a leave from his firm in order to travel and study in Europe. His trip lasted two years, during part of which he was officially enrolled at the Ecole des Beaux-Arts in Paris, at that time the most highly regarded international academy for the study of architecture. At least a year of his trip was spent in on-site study of architecture. His notebooks and sketchbooks show that he traveled through France, Germany, and Italy, where he drew monuments in Rome, Venice, and Pisa. He was issued permits by French ministries to draw and paint in palaces throughout France and in the major museums of Paris.

The sketches that survive from Sawyer's study trip show him to have been especially interested, even at this youthful age, in masonry architecture and in the details of architectural ornament in particular. Thumbnail sketches record portions of ornamental friezes in the Lateran Museum at Rome, a detail of a mosaic pavement from the House of Olivia at Pompeii, and a ceiling pattern at Rome. Several of Sawyer's drawings show his interest in Italian palace design of the fifteenth and sixteenth centuries, such as a full-page drawing of a Renaissance palazzo with rusticated stonework (masonry cut in massive blocks separated by deep joints, usually on the lower story of a building). Two others record a sixteenth-century building and doorway in Venice in the Mannerist style. The Italianate Renaissance palace design with rusticated masonry was to become a signature building type of Sawyer's in his later professional work. In

all of the drawings he did in Europe, Sawyer shows an intimate understanding of the principles of classical design as well as an accuracy of detail. Sawyer would have returned from this experience at the age of twenty-six with a thoroughly integrated knowledge of European historical architecture of a sort impossible to obtain without leaving the United States.

Other Buildings by York & Sawyer

In 1898 York and Sawyer both left McKim, Mead, and White to form their own partnership. In their long list of commissions for buildings in New York, Washington, and other cities of the East Coast, they employed the architectural values and principles promoted by McKim, Mead, and White, while achieving their own perfection of style. Typically this style was characterized by an exterior order and severity set off by an interior richness. Besides the embracing of order and rationality in plan and elevation, other leading concepts that York and Sawyer took from the more famous firm were their interest in designing buildings in groups or complexes and their sense of the architectural value of symbolic and associational references to the past.

The firm of York & Sawyer specialized in banks, hospitals, and colleges. Like that of McKim, Mead, and White, most of their work was classical, patterned either on ancient Roman or Italian Renaissance construction. The firm was known for the striking visual effects of the exterior of its buildings, frequently obtained through the use of rustication. Among the long list of their designs, some outstanding works are the Guaranty Trust Company (1913), Manufacturer's Hanover Trust Company (1914), the Bowery Savings Bank (1922–23), the Fifth Avenue Hospital, the Federal Reserve Bank (1925)—all in New York City—and the Department of Commerce Building in Washington, D.C. (designed 1913). Besides the clear rationality of the plan, what all these buildings have in common is the thorough understanding of period styles visible in the elevation and the decorative ornamentation. They show York & Sawyer perfectly at home working with historical building practices. Most of their buildings are not copies of specific historical buildings. Rather their works illustrate an intelligent facility to analyze his-

Facing page:
Portal and facade,
Bowery Savings Bank
(1923)

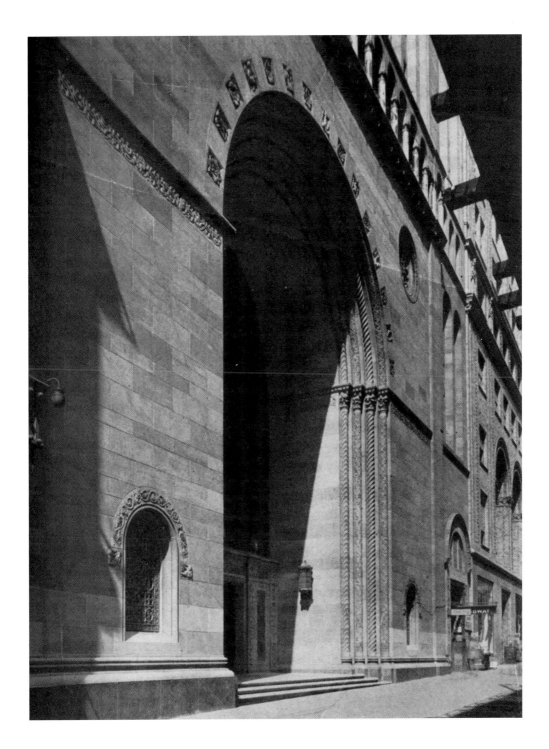

torical practice and to reformulate elements of period styles into
new designs. For example, in the Bowery Savings Bank, the
ornamented portal of Italian Romanesque design is flanked by
perfectly conceived recessed columns of alternating twisted and
diamond patterns. In a manner never seen in true Romanesque

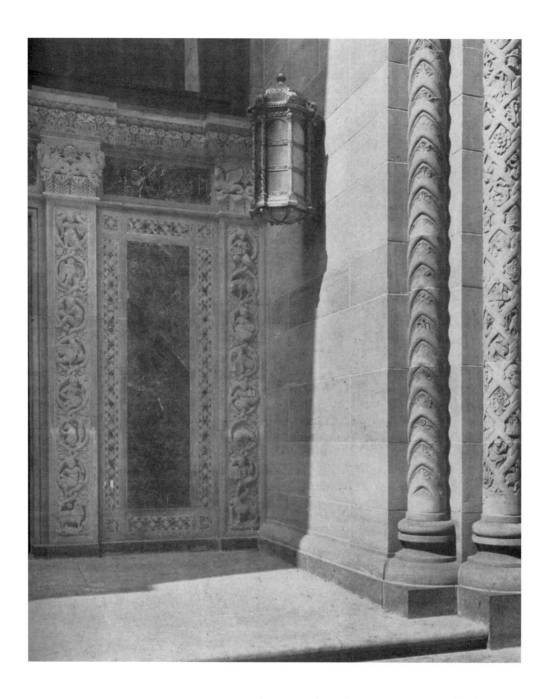

*Detail, Bowery Savings
Bank exterior*

construction, however, the columns are immensely elongated to form a colossal order appropriate to the scale of the portal and the facade.

The experience of York & Sawyer in designing multi-building campuses is important to the Law Quadrangle commission. One of their earliest was the complex at Rockefeller University, New York (originally called Rockefeller Institute for Medical Research) (1903–10), a campus for research and

advanced education; the Allegheny General Hospital in Pittsburgh (1929–36) with its Nurses' Home and dormitories; and the designs for Vassar College (1899), Middlebury College (1903), and Rutgers University (1911).

The New York Academy of Medicine (1927) and the Allegheny General Hospital in Pittsburgh are among the major designs by York & Sawyer in Medieval style. They are far removed from the English Gothic conception of the Michigan Law Quadrangle; nevertheless, the way in which York & Sawyer interpret Medieval style in these buildings assists an understanding of the Law School buildings. The exterior decoration of the Allegheny General Hospital is eclectic, of an essentially Byzantinizing character that recollects both Early Christian Constantinople and late Medieval Venice. These styles are recalled in the use of granite and marble column shafts on the entrance portico that carry late Roman–Early Christian basket capitals with stylized acanthus leaves. The yellow industrial brick construction hints at an Art Deco freedom of interpretation. A similar imaginativeness in the decorative elements characterizes York & Sawyer's Academy of Medicine at Fifth Avenue and 103d Street. In this case, however, the architects have given the building a Lombard Romanesque design, with elements of north Italian building of the tenth to twelfth centuries. The ability of the firm to work in an array of historical styles is nowhere more evident than here. The main entrance in the 103d Street facade is framed by columns carrying capitals, and the architectural details are all perfectly conceived according to Romanesque practices of jamb construction. The paired lions flanking the portal and the window corbels with crouching atlas figures in conjunction with animals—real and fanciful—have all the imagination of genuine Romanesque sculpture.

The Cathedral School at Washington, D.C.

Though Gothic-style buildings are relatively rare in the repertory of York & Sawyer, their building for the Cathedral School for Boys at Washington, D.C.—the Lane-Johnston Building at the institution now known as St. Albans School—prefigures important elements of the Law Quad at Michigan. Philip

79

Sawyer received the commission from the Cathedral School by competition in 1904 with his design for a Gothic building of Potomac blue stone with white limestone trim. It was constructed between 1905 and 1907 and originally housed dormitories, classrooms, and the headmaster's quarters. In the Lane-Johnston Building, conceived in a sober version of the late Gothic Tudor style, the firm of York & Sawyer employed design features which they subsequently enriched and elaborated in the sumptuously endowed Lawyers Club project at Michigan. Allusions to the Tudor style in the Cathedral School appear primarily in smaller elements of the elevation, such as the wide pointed arches on the ground floor, paired windows of the second, and diminutive half-timbered dormers above. These elements are overwhelmed, however, by the prominence of the roughly cut, almost crude masonry coursing, more suggestive of early Medieval stone construction in the British Isles. The element that was to reemerge in the Law Quadrangle and that identifies these two projects as the work of York & Sawyer is the deliberate visual playing off of massive and dark-toned wall masonry by finely cut white limestone accents framing portals and window openings and emphasizing linear values. In the Law Quad buildings the contrast is of greater richness because the use of multihued, seam-faced granite and the multiplication and enlargement of window openings. This eye for surface richness and texture was considered a trademark of York & Sawyer designs.

Nevertheless, most of the buildings by York & Sawyer are more sober than Michigan's Law Quad. This is in part explained by the differences in building types and their functions. So many of their buildings were banks, and these have an appropriately simple and geometric profile that has been called "vault-like." At the same time, differences in the results York & Sawyer achieved may reflect what they considered appropriate to different historical styles and what these styles said in different ways, about the past. The predominant styles in which they worked, the ancient Roman and Renaissance Italianate, were both based on classical ideals of sobriety, rationality, and a balanced perfection. Judging by the Bowery Savings Bank, Pittsburgh's Allegheny General Hospital, the New

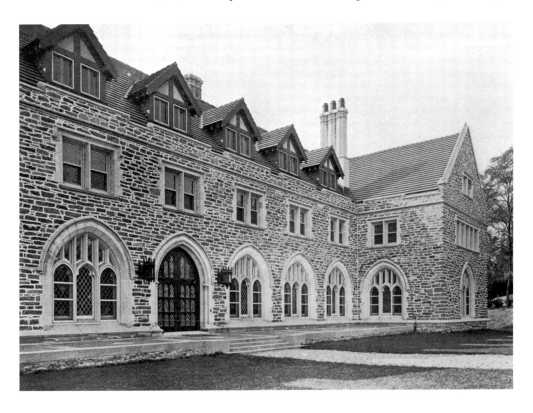

York Academy of Medicine, and the Michigan Law Quad, York & Sawyer evidently believed that the use of Medieval styles allowed for more fantasy and whimsy—at least in the realm of ornament—and that a more decorative surface texture altogether was permissible in the anticlassical realm of Medieval design. The Law Quad at Michigan may be described as the most grandiose and developed expression of these ideas within the work of York & Sawyer.

The Lane-Johnston Building, St. Albans School, Washington, D.C. (1907)

Building Methods in Construction of the Law Quadrangle

But what about that aspect of building history that tells us how things were actually done at the building site? How were the buildings put up and what kinds of building methods were used? In addition, the presence of so much sculpture and decorative work on the Law Quad buildings prompts questions about how this aspect of the whole design was accomplished.

This category of information has a life of its own in instruc-

tional manuals for the buildings trades or in general studies of architectural construction. But this does not tell us how things were done during the course of a particular project. This kind of information—the day-to-day history of a building as it was going up—is rarely written down, or else it is discarded after the project is complete. We would like to be able to hear the story from the builders and workers themselves, and from observers like Dean Bates. Unfortunately, this kind of firsthand remembrance usually does not survive the lifetime of the witnesses either.

These caveats aside, a few interesting revelations about the working methods of York & Sawyer do emerge from records of the project. York & Sawyer used only New York contractors and builders; no local Michigan or even Chicago firms were used. This is not surprising, since, like other architectural firms, York & Sawyer would have offered, for bidding, the names of contractors whose work and reputation they were thoroughly familiar with. Before construction began, Cook himself hired the New York firm of Marc Eidlitz & Son, whom he referred to as "the leading builders in New York City," to draw up an estimate of the cost of the entire Quadrangle and to supervise the carrying out of the contracts. The choice of Eidlitz to work up figures for the Gothic-style Law Quad is a measure of Cook's sound and shrewd ways of proceeding, and he may have been directed, as he was in other architectural matters, by the experience of York & Sawyer. Eidlitz was the chief contractor for John D. Rockefeller's Romanesque-style museum, the Cloisters, on the banks of the Hudson in New York. For that supremely well-built building, Marc Eidlitz & Son hired European stonemasons to cut the fabric of the building according to Medieval practices.

The contractor selected for the Law Quad was Starrett Brothers of 50 East Forty-first Street, New York. Other participating firms were Ricci & Zari for the hand-carved decorative stonework of the exterior, The Hayden Company for the interior furnishings and cabinet work, and James Baird Company for the stonemasonry and the plaster ceilings in the Legal Research Building. Of these firms, at least one of them, the stonemasons, James Baird Company, must have set up a tem-

porary workshop, or atelier, in Ann Arbor. A James Baird Company is listed under "Contractors" at the address of 711 Monroe Street in Polk's *Ann Arbor Directory* for 1930 (a kind of early yellow pages of Ann Arbor tradesmen). In the 1932 *Polk's,* Baird is no longer listed and the Monroe Street address is occupied by the Wolverine Stone Company.

During the preparations for construction of the Lawyers Club, Edward York, accompanied by the president of Starrett Brothers, personally visited the famous limestone quarries of Indiana. York wrote to Cook in July 1923: "I am off on the eleven o'clock train to Bedford, Indiana, with Colonel Starrett to see if the limestone people are giving us the right selection of their material." Another letter to Cook followed in three days:

> I have just returned from Bedford, Indiana, and find they
> have made a good start on the limestone trimming. There is
> so much of it that it is being gotten out in two different
> mills, and I am very glad to have had a chance to talk to the
> foremen of the shops who are actually responsible for their
> product. I feel they understand now just the effect we are try-
> ing to get and are enthusiastic over the result.

This kind of personal attentiveness to every element of the building process was part of the high standards associated with the firm of York & Sawyer.

Another interesting aspect of the building methods was the sculptors' use of plaster models to guide them in the carving of the figurative and decorative portions of the exterior stonework. These models were provided for—as well as the means of their disposal afterward—in the "Specifications" (the detailed contract between the architects and the contractor). The contract for the John P. Cook Dormitory provides:

> The contractor shall include in his estimate . . . the cost of
> plaster models for all exterior carved stone work, which will
> be made by a modeler to be selected by Architects, and shall
> be paid for by the contractor. The models will be delivered to
> the contractor at the modeler's shop in New York City, crat-
> ed, ready for shipment At completion of work the mod-
> els shall be delivered to the Architectural School at the Uni-
> versity of Michigan.

Plaster models of stonework details awaiting shipment to Ann Arbor from the shop of Ricci & Zari in New York for use by the stonecarvers on site

We hear of another such model, this time for a piece of interior stonework, later in the document (still referring to the John P. Cook Dormitory): "The contractor shall include . . . the cost of plaster model of stone mantel in the Memorial Room, which will be made in New York City by a modeler selected by the Architects and be paid for by the contractor When carving has been executed, model shall be delivered to the University of Michigan, School of Architecture." The present whereabouts of any of these models, if they survive, is unknown.

A letter from York to Cook of 23 October 1923 further explains:

> There are one hundred forty full-sized models which are
> being made here in town, the largest being about 6 ft. × 4 ft.

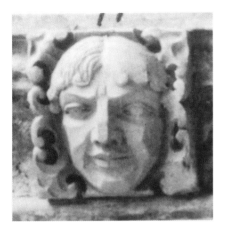
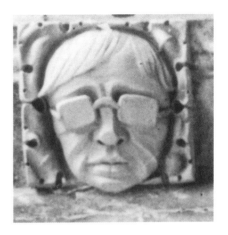
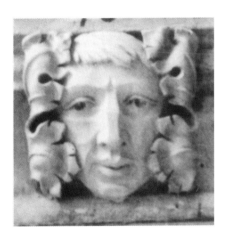
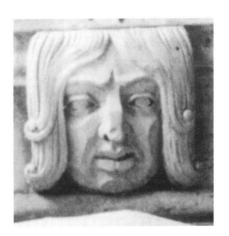

> We first make the drawings for this work and then have the
> models made in town so we can keep track of them and cor-
> rect them from time to time as they go along. After we are
> satisfied, a plaster cast is made and shipped to the job shop,
> for the carvers to execute their work. The cabinet work is
> erected in the shop but the stone is roughed out at the quarry
> and carved on the building.

When York says they are having the models made "here in
town," he means, of course, in New York City. The firm hired
to create the plaster models was Ricci & Zari of New York;
their assignments would have included models for everything
from the famous series of university presidents on the corbels
of the main entrance arch into the Quad, to the amusing

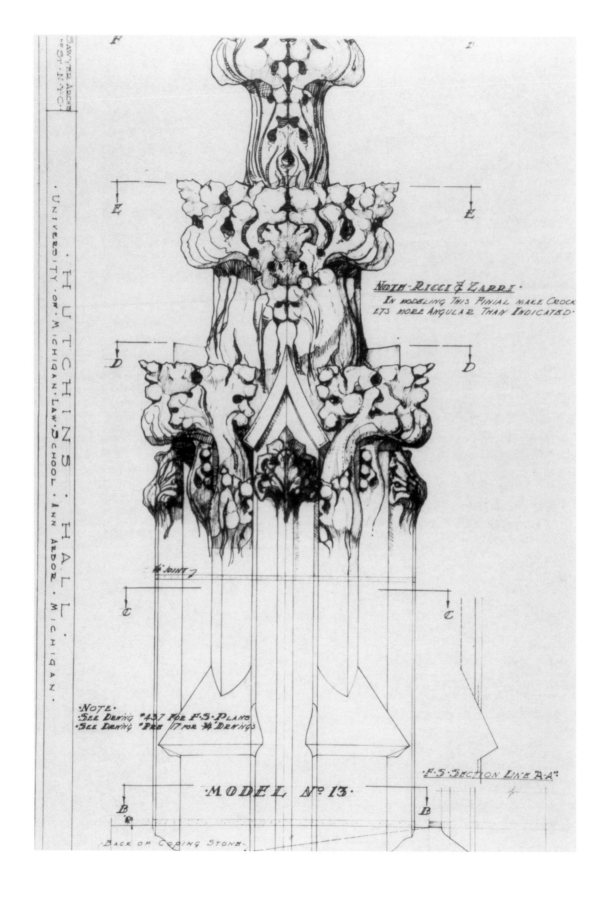

NOTE–RICCI & ZARRI.
IN MODELING THIS FINIAL MAKE CROCK
ETS MORE ANGULAR THAN INDICATED.

·NOTE·
·SEE DRWNG *437 FOR F·S· PLANS
·SEE DRWNG *PRS 117 FOR ¾· DRWNGS

·F·S·SECTION LINE "A-A"·

·M·O·D·E·L· N° 13·

·BACK OF COPING STONE·

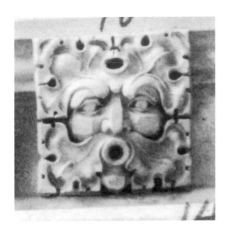
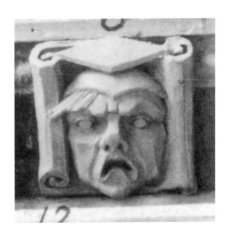

heads framing windows and doorways of the John P. Cook Building, to the pinnacles rising from the corners of the Legal Research Building.

The amusing and well-loved sculptured figures that emerge from every corner are known to all who frequent the Law Quadrangle. The use of prepared models turns the making of these animated figures into a decidedly two-stage process. In other words, the designing of the figures, their postures, and whatever symbolic attributes they might carry, was a process entirely separate from their actual carving. Workmen on the spot, possibly those of the James Baird Company, would have done the carving, but it would have taken artists with a special knowledge of Gothic stone sculpture and a facility for the imaginative interpretation of this style to create the expressive three-dimensional models required.

Facing page:
York & Sawyer drawing for finials on Hutchins Hall tower with note to sculptors Ricci & Zarri [sic]: "make crockets more angular than indicated."

87

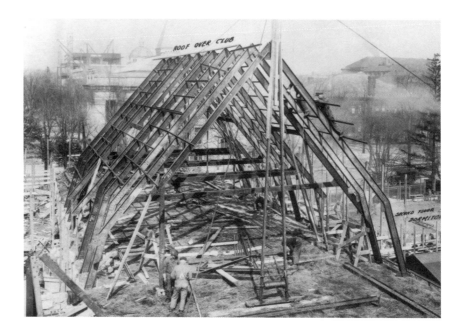

Above: *View of dormitory and Lawyers Club, second floor. Shows roof of Lawyers Club under construction, revealing the steel skeleton. Though the finsihed building appears to be of solid stone construction, like a structure of the Middle Ages, this photo gives an idea of the large amount of steel used in the construction of all the Law Quadrangle buildings. 28 February 1924*

Below: *Dormitory seen from the corner of Tappan and South University. Shows the layering of the outer walls with ashlar (dressed stone) with layer of brick behind. 28 February 1924*

The Photographic Documentation of the Building Progress

The most revealing sources for the process of constructing the Law Quadrangle are the progress photographs taken while the buildings were going up. The agreement between York & Sawyer and Starrett Brothers provided that cameras should be set up at four stations around the building site to record the building progress, every two weeks, summer and winter. Letters indicate that Cook was sent one set of these photographs

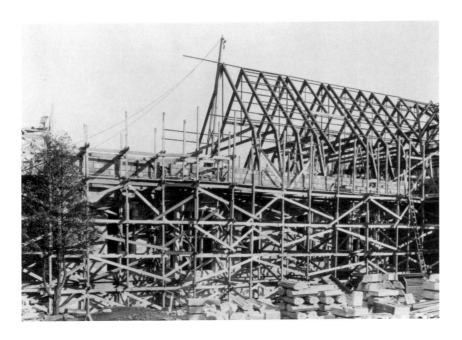

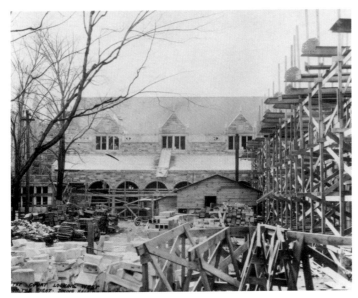

Above: *Corner of South University and State Street. Steel skeleton; outer walls under construction. Shows the large role played by wooden scaffolding. On the ground can be seen the piles of ready-cut architectural stones (moldings and vault springers). 15 March 1924*

Below: *Lawyers Club seen from the interior court, looking west. The dormitory is on the right; the dining hall is on the left. Shows the stonemasons' work yard set up inside the courtyard, with wooden roofed building to protect equipment. The cloister walk and the floor above it are already completed. 17 April 1924*

as early as August 1923 and continued to be sent copies throughout the project. The accompanying plates illustrate a selection of photos of the construction of the Lawyers Club from 1923 and 1924.

While the exterior of the Law Quad has hardly changed in the sixty to seventy years since its construction, the interior appointments have undergone certain alterations, as necessi-

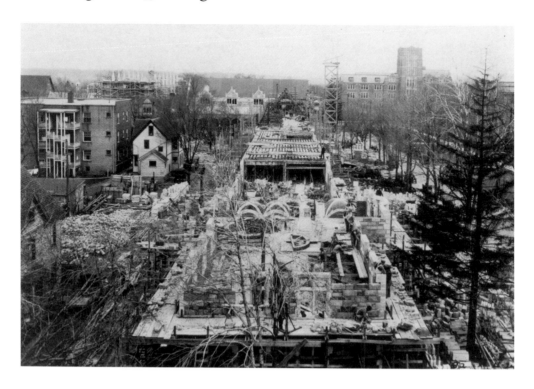

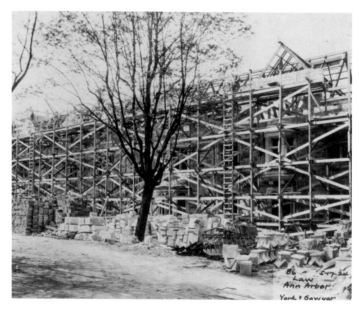

Above: *View looking west from the Martha Cook Building. Shows the steel substructure of the vaults of the Lawyers Club. Also visible is the wooden centering used in constructing the stone arch (this centering, of course, would be removed and discarded); and laying of the ashlar stones of the outer walls. 24 April 1924*

Below: *Dormitory seen from the courtyard, west of tower. Complete up to third story. Photograph shows pre-cut pyramidal stones identifiable as terminations for the gables. 5 May 1924*

tated in a building that has been constantly in use. In the following chapter, the tour through the notable rooms of the Law School will highlight the original character of the rooms and note the reasons for any changes where those exist.

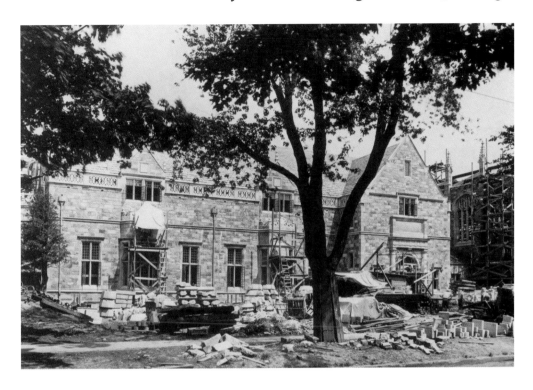

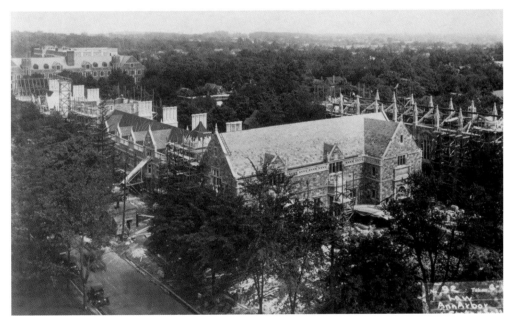

Above: *General view from State Street and South University. Photograph shows facade of main Club entrance nearly complete and the construction yard. 18 June 1924*

Below: *Panoramic bird's-eye view. Portions of buildings complete, others still unroofed. 18 June 1924*

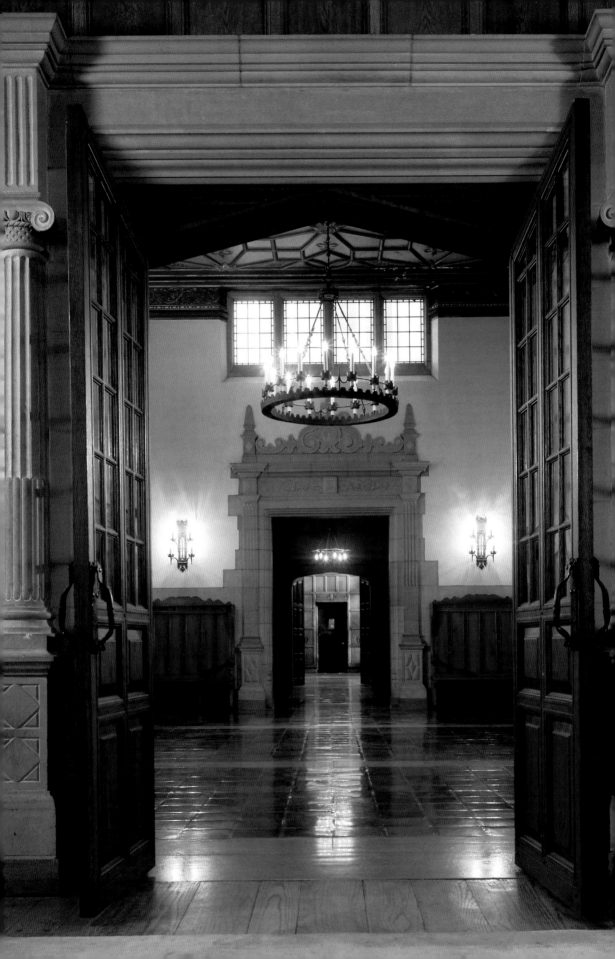

Inside the Law Quadrangle:
A Descriptive Tour

A hallmark of buildings designed by York & Sawyer is the rich treatment of the interior, created by contrasting materials and superb workmanship. These standards are everywhere in evidence on the interior of the Law Quadrangle, in the individual rooms, and in the communal spaces that connect them. Like the exterior, the interior rooms were conceived in terms of the English Gothic and Tudor styles. The Gothic style seems to have been selected when grandeur was wanted (as in the Dining Hall and the Reading Room of the Legal Research Building), while the Tudor style was the choice for the more intimate spaces.

In their realization of a historically true interior decoration for the Law Quadrangle, York & Sawyer made use of some of the finest firms still practicing specialty handwork in woodcarving, plastering, and metalworking in the 1920s and 1930s. Not all the names can be recovered, but for the Lawyers Club, the John P. Cook Building, and Legal Research, The Hayden Company of New York was the principal contractor. The Hayden Company, founded in 1846, had its factory in Rochester, New York, and advertised its specialties as "reproductions of old furniture, antique furniture and tapestries, old velvets and brocades, and interior woodwork." Its task, in fact, was a monumental one, the most challenging part of which was to be the construction of the Gothic-style hammerbeam ceiling over the Lawyers Club Dining Hall. Much of the work was done in the Hayden factory, but for a project as varied and demanding as the Law Quadrangle, the firm counted on subcontractors to supply parts of the work: the Aladdin Iron Works of Syracuse and Reed and Hardy of Rochester for lighting fixtures; Hubbard, Eldredge, and Miller of Philadelphia and Elgin A.

Facing page:
*Lawyers Club lobby,
looking toward Dining Hall
from lounge*

Simonds' Company of Syracuse for furniture; and Horn & Brannen Manufacturing Company of Philadelphia for fixtures. Edward F. Caldwell & Company of New York also supplied ornamental brass and wrought-iron work for the Lawyers Club. Over the years, as repairs and renovations have been necessary, every effort has been made to maintain the rooms of the Quadrangle in their original state, except in the replacement of ephemeral items of furniture or when changes have been required for functional reasons, as in some of the classrooms.

The Lawyers Club

Upon entering the Quadrangle from any of the vaulted entrances along South University Avenue, the visitor can enter the earliest portion of the complex—the Lawyers Club—by passing through the columned arcade that runs along the building's north wing and entering through the heavy wooden door located in the east wall. The door opens directly into the lobby, a large and high space that has two major decorated portals in its north and south walls—the one on the visitor's right opening into the Student-Faculty Lounge and the one at the left into a small foyer leading to the Dining Hall. Both these portals have elaborate sculpture and decorated moldings of white limestone, and they have been designed as a pair, though they do not match exactly in every detail. The portal opening into the lounge is framed by fluted pilasters topped by a lintel with a pattern of foliate rinceaux and rosettes. This framework supports a massive entablature in late Renaissance style, featuring paired urns and scrolls framing a tablet with the following words:

THE LAWYERS CLUB
FOUNDED APRIL 1922 BY
WILLIAM W. COOK

A.B. 1880 LLB 1882
OF THE AMERICAN BAR

The opposite portal into the Dining Hall is closely matching in the design of its architectural framing devices, but instead of a commemorative tablet, its scrolled entablature carries a circular medallion at the center, displaying a figure of Justice. The other

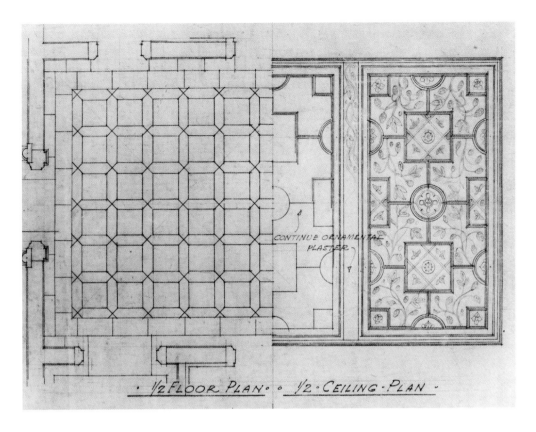

· ½ FLOOR · PLAN · ° · ½ · CEILING · PLAN ·

CONTINUE ORNAMENTAL PLASTER

doorways in the lobby are less grandiose but are similarly framed in white limestone with great attention to the accuracy of such details as the architectural moldings and bases, carved in the late Gothic style of sixteenth-century Northern Europe. The pavement of the lobby is of brown Welsh tiles, and the same paving is found on the stairs and halls of the dormitories of the Lawyers Club.

The ceiling of the lobby is of painted plaster, supported at the center by two great beams. Its decorative motifs include fleurs-de-lis, rosettes, and delicate stemmed rinceaux in a color scheme that is predominantly red and gold with small amounts of green. Such a painted and gilded display might strike the modern viewer as gaudy, but it is an authentic recreation of late Gothic ornamental taste. Originally the decorative scheme of the lobby included a pair of tapestries of Renaissance date, Cook's most valuable gift of artwork to the Law School. Correspondence between Edward York and Cook reveals that the architects specifically designed the lobby of the Lawyers Club to

York & Sawyer drawing for ceiling and floor, Lawyers Club lobby

95

feature these tapestries. They have since been moved to the Faculty Commons Room in Hutchins Hall for safekeeping (see below, description of the Faculty Lounge or Commons Room), but they would originally have hung opposite each other in the large wall spaces above the entrance portals from the Quadrangle and from State Street. The deep colors of the tapestries and their depiction of fruits, flowers, and verdant foliage would have complemented the rich decoration of the painted ceiling, in keeping with the late Gothic taste for ornamenting all surfaces, including architectural ones. A third tapestry, even earlier in date and part of the same donation from Cook, originally hung in the Student-Faculty Lounge. It is presently in storage at the University of Michigan Museum of Art.

The Student-Faculty Lounge

The Student-Faculty Lounge of the Lawyers Club is later in style than either the lobby or the great Gothic Dining Hall adjacent to it. Its design and architectural decoration are based on the style one might find in a Tudor country house of sixteenth-century England, lending the room a sense of comfort and richness entirely appropriate to its function. The lounge is a long rectangular room, eighty-four feet long by thirty-four feet wide and terminating in a large semicircular bay lighted by tall windows. The floor is made up of wide white oak planks fastened together by dowels.

The ceiling, perhaps the most striking aspect of the room, takes the form of a shallow barrel vault. The vault rests on broad rectangular piers separated by niches of space or simple recessed window alcoves. Where the curve of the ceiling meets the vertical supports below, a wide decorative molding of three bands runs continuously around the room, overlapping the supporting piers. The rich decoration of this molding, featuring vine rinceaux, rosettes, and other repetitive motifs in relief, reinforces the Renaissance character of the room. A polished oak wainscoting, made up of rectangular panels, lines the walls of the room to a height of eleven and a half feet and terminates in a pattern of denticulation.

The plaster ceiling of pale ivory is a prized example of an architectural art that is no longer practiced in public buildings

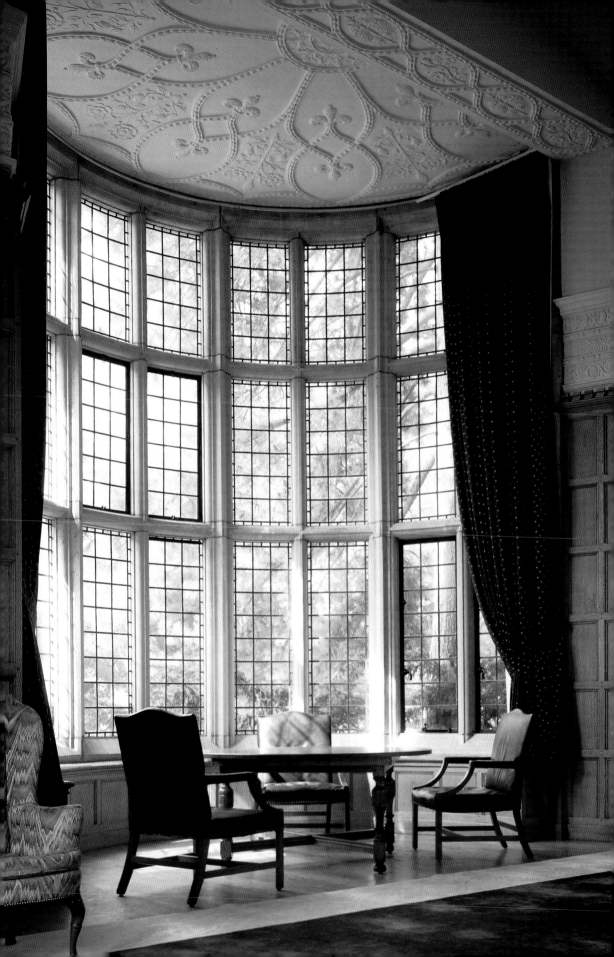

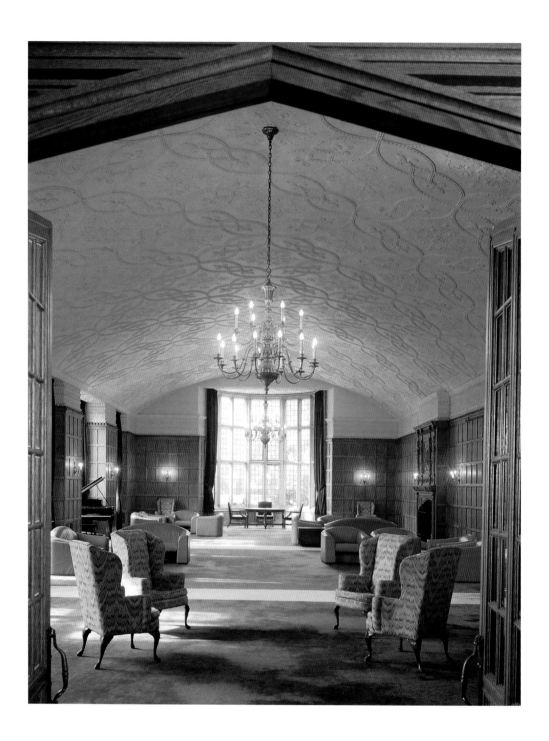

Lawyers Club lounge

in America. Its subtle decoration has been achieved without a vestige of color. The design is created, instead, by plaster motifs in a range of high and low relief. The surface of the ceiling is broken into medallions framed by slender ribbonlike elements that form interlace and terminate in fleurs-de-lis. At the center of each medallion is a delicate and complex motif in low

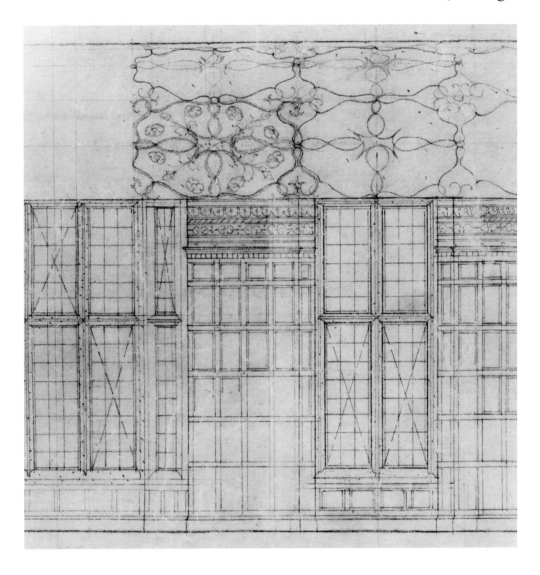

relief—a rosette, cone, or stem in quadripartite patterns. The viewer will notice that the same distinctive motifs appear in other contexts throughout the room—double rosettes on a stem and fleurs-de-lis on the flat ceiling of the windowed bay at the end of the room; the thistle and rosette with grape clusters on the underside of the lintel at the entrance into this bay; rosettes on the wide plaster molding encircling the room. This kind of decoration, with its unfolding visual interest, rewards the close examination of the interested observer, but for those simply seeking relaxation, it provides surroundings of comfort and ease for the eyes.

York & Sawyer drawing for Lawyers Club lounge ceiling

99

Another focal point of the lounge is the heavily sculptured wooden fireplace mantle on the east wall, carved from the same dark oak as the wainscoting. This elaborate display of the wood-carver's art makes playful and irreverent use of classical elements in a way that is clearly based on a Mannerist conception of classical forms (that is, the sixteenth-century style in which artists deliberately created "mannered" distortions of Renaissance formulas for expressive purposes). For example, the lower supporting structure of the mantle is formed of sober fluted pilasters that frame the fireplace and appear to support a display of fantasy architecture above. Even the fluted pilasters violate classical norms, however, since the flutes are done in reverse—carved as convex rather than concave channels running the height of the pilasters. The superstructure of the mantle features four figures of antique herms that are decidedly Mannerist in style and spirit. The herms are perched atop anticlassical pilasters that taper toward the bottom rather than toward the top, and their faces and coiffures are in characteristic Northern Renaissance style. The two outer herms are a pair, as are the two inner ones. The limestone fireplace itself is very simple in design, carved in the form of an architectural door frame with concave and convex moldings. The arms of the grate terminate in dragons' heads with flat noses and bared teeth, cousins to the dragons in the porch of the Monroe Street entrance to Hutchins Hall.

The final touches to the decorative ensemble of the Lawyers Club lounge are the brass wall sconces placed at intervals along both walls and the two handsome chandeliers of curvilinear design, situated at opposite ends of the room. The only doorway into the Student-Faculty Lounge, the one from the lobby, whose elaborate carved limestone frame has already been described, also has a carved frame of limestone on its inner side. Its structure is made up of columns in Ionic style, supporting a very plain entablature, and its design is severe compared to the two decorated portals facing into the lobby.

Dining Hall

The Dining Hall may be entered from the lobby of the Lawyers Club or from the courtyard of the Quadrangle, where a pair of

Facing page:
Lawyers Club Dining Hall

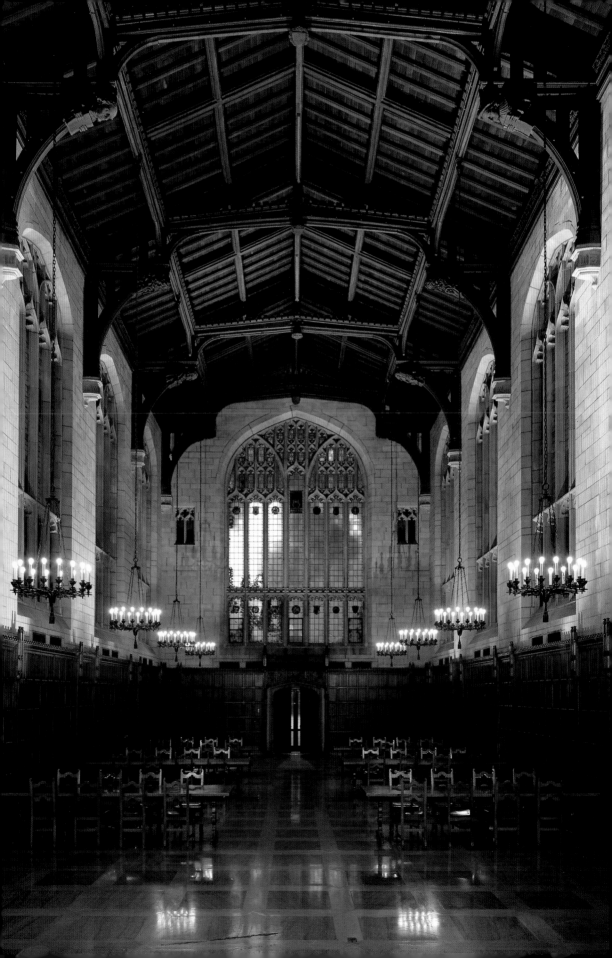

heavy wooden doors form the main entrance on the building's east side. The interior of the hall is one of the most breathtaking architectural spaces on the Michigan campus. Photographs only weakly convey the vast unobstructed volume enclosed by this building. Its design is a simple elongated rectangle, 140 feet long by 34 feet wide, and composed of eight bay units. The hall soars 50 feet from floor to ceiling. In the realization of the design York & Sawyer avoided a boxlike confinement by opening more than half the height of the side walls with glass. The two matching end walls at east and west are also given over almost entirely to pendant tracery windows. The initial sensation for the visitor is of a breathtakingly vast and high space into which light pours, as through a grid. The design, in fact, approximates very closely that of an English Gothic hall with flat end walls and a massive timbered hammerbeam ceiling. The solid wall areas and the window tracery are of white, finely cut limestone, while the lower walls are covered, as in the lounge, by paneled wainscoting of oak. Twin rows of eight hanging, wrought-iron chandeliers of wheel design are the only artificial light source. The floor has a simple pattern of polished marble panels of veined rose set into a pale gray marble frame. The decoration includes all the arts that would have been part of a grand and ceremonial banqueting hall of the fifteenth century in England—in particular, grandiose examples of the wood sculptor's art, as well as stained glass and decorative metalwork. York & Sawyer's "Specifications" for the special interior woodwork for the Lawyers Club (including the Dining Hall) calls the contractor's special attention to the architects' desire "to obtain, as far as possible, a result in woodwork which will give an air of semi-antiquity, but without a too apparent attempt at imitation of old work. The atmosphere of the old work must be obtained by the general methods of putting the work together, its details, the feeling, design and execution of the carvings, the treatment of woodwork in staining and finishing, and in getting a handworked result."

The values celebrated in the Gothic-style Dining Hall are those of history and tradition. These are conveyed not only in the overall design of the hall but in the presence of symbolic motifs worked into the decoration. For example, visual symbols are incorporated into the heavily sculptured wooden canopy

that frames the principal (east) entrance into the Dining Hall on the inner side. This elaborate work of wood carving is architectural in design and scale and recalls the massive canopies that traditionally framed the painted altarpieces of late Gothic churches. In the Dining Hall of the Lawyers Club, however, the visual symbols all refer to the secular worlds of academia, the law, and government. At the center of the canopy, above the door, is an escutcheon carved with an initial **M** for Michigan. Another escutcheon at the far left shows a male figure holding a rifle and observing a rising sun. Carved next to the image is the Latin word TUEBOR from the verb *tueor*, meaning both "to gaze upon" and "to watch over, protect, and defend." The significance of this emblem is that it forms the central motif on the great seal of the State of Michigan, designed by Lewis Cass and adopted at the Constitutional Convention of 1835. The corresponding panel at the right depicts a lighted oil lamp sitting atop a pile of books. These two motifs—the sentinel with radiant sun and the lamp of wisdom—are pictured over and over again on the interior of the Dining Hall, in the sculptured woodwork and the stained-glass windows.

The giant windows of the Dining Hall are based on a similar design derived from Perpendicular Gothic patterns: a short row of vertical panels along the bottom supporting a much taller, elongated row above, terminating in pointed arches filled with tracery patterns in the upper zone. It is the rapid elongation of patterns from bottom to top that gives the windows their remarkable sense of rise and lift. They are also true to their late Gothic models in that the glazing creates an overall monochrome effect. The individual window panels have only the palest hint of color—mauve, or pale yellow panels interspersed with a preponderance of colorless frosted glass. The only real color occurs in the small roundels and shields located at the top of each of the vertical panels in the windows of the two end walls. Consequently, the overall quality of light flooding into the Dining Hall is bright and natural, not subdued. This was the effect sought in the late Gothic development of monochrome glass—what the French call *grisaille* or grayed glass—to distinguish it from the deeply saturated colors of stained glass in earlier centuries.

Typically the grisaille panels were enlivened by a few small areas of intense color, and the formal shields and escutcheons in the end windows play this role in the Dining Hall. In the east window one group represents the various schools of the University of Michigan—Medicine, Engineering, an owl for Literature, Science, and the Arts. The image of the rifle-carrying sentinel, here observing a burning red sun, appears twice in this window, once in the lower register and in the tallest central panel, where it is flanked by an elk and a moose in the fully elaborated seal of the State of Michigan adopted in 1911. In the central panel the seal is flanked by signs of the zodiac. The opposite west window has an identical design and arrangement, but the lower row of shields has varied images: a scales of Justice, a lemon tree, a cornucopia. At the center is a lighted lamp of knowledge. In the tallest vertical panel at the center a large golden lamp of knowledge appears a second time, resting on a stack of books and with a red sun above. Below the lamp is the motto of the University of Michigan, ARTES/SCIENTIA/VERITAS, and the date 1837. The latter has a double significance as the year in which Michigan was admitted into the Union as the twenty-sixth state and the year in which the Michigan Legislature simultaneously chartered the University of Michigan as a state university and directed that a Department of Law be established at Ann Arbor. Signs of the zodiac flank this central image, as in the east window.

On the long north wall of the Dining Hall is the doorway into the lobby. This entrance also has a carved wooden framework, less grandiose and without the demi-canopy of the east entrance but sharing many of the same Flamboyant Gothic tracery patterns in its wood carving. The same recurring symbols found throughout the hall are also present here. Directly above the door is a carved scroll with the University of Michigan motto; above this is a lighted lamp of knowledge atop an open book, the date 1837 in large numerals above it.

The weighty hammerbeam ceiling is one of the most remarkable aspects of the Dining Hall interior. Its design combines features of the traditional tie-beam roof with a late Gothic creation, the hammerbeam ceiling. Examples of tie-beam ceilings similar to that erected by The Hayden Company at Michi-

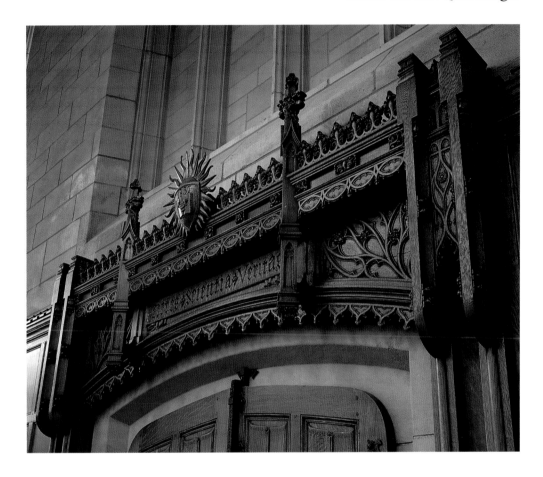

gan can be seen at Long Sutton, Somerset, and the chancel of St. Martin's, Leicester. English timber builders were particularly adroit in exploiting the technical innovation of the hammer-beam, and numerous variations of this construction still exist, for example at West Walton, Norfolk; Earl Stonham, Suffolk; and Knapton, Norfolk. As a solution to the problem of roofing over a vast interior space without using intermediate vertical supports, ceilings of this type fused two arts at which English Gothic builders excelled—timber and stone construction. The weight of the massive ceiling beams is carried ultimately by the limestone walls below, where the timber wall posts fit down onto stone cul-de-lampes or corbels that are bonded into the masonry. The marvel of the ceiling, though, is the carefully interlocked system of struts and posts, of which the projecting hammerbeams are the most ingenious. These deflect some of the ceiling's weight horizontally before it reaches the walls.

Woodwork above north door of the Dining Hall

105

The president of The Hayden Company, I. Elbert Scrantom, kept Cook personally apprised of progress on the Dining Hall ceiling. Scrantom was closely involved with all the interior work for the Lawyers Club, frequently visiting the site, and he personally hung the three Cook tapestries in the lobby and lounge. In a letter of 24 August 1923 he wrote to Cook: "The large beams are now coming into the factory and are being put on sticks for the necessary drying. The first carload has arrived and the balance is expected within a fortnight. As soon as the wood is in condition we shall be able to fabricate the ceiling, which I understand is the first requirement of the building." By 6 December 1923 he was telling Cook: "You will be pleased to know we are hard at work upon the ceiling of the dining hall. I wish you might see this under construction. Our man is at the building now taking the necessary measurements for proceeding with the wainscoting, etc., in the several rooms, and a good portion of our factory will be going full time on your work in the near future."

In the design of the Dining Hall ceiling, the arch braces below the hammerbeams were made to carry sculptured images along their inner curves. Surviving letters of 21 and 28 February 1924 from Edward York to W. W. Cook reveal that these are meant to represent the ancient lawgivers of the world. The program was still in the planning stage when these letters were exchanged, with York suggesting Confucius, Moses, Solon, Aristotle, Gellius, Cicero, Caesar, Pliny, Marcus Aurelius, and unnamed authorities on canon law as possible candidates for inclusion. It is unclear how many of these historical figures were finally incorporated into the program as it exists, since not all the hammerbeams carry busts and some of the busts are duplicates. In *A Book of the Law Quadrangle* of 1934 (pp. 52–53), the series is said to include Solon, Justinian, Grotius, Blackstone, Coke, Marshall, Webster, Story, and Cooley. What is not disputed is that the figures were handcarved following models created by a sculptor (letter of 28 February 1924 from York to Cook). Each figure holds an unfurled scroll (the traditional attribute of a lawgiver), and such variations as full wig/soft Medieval cap or full beard/beardless can be distinguished among them.

The Cook Memorial Room

The second building constructed under William W. Cook's bequest, the dormitory that parallels Tappan Street, was named by Cook after his father, John Potter Cook. Within the building is a specially maintained room dedicated to the memory of the

Bay, Cook Memorial Room

elder Cook. The room can be entered from the Quadrangle, through the door into section N of the John P. Cook Building. A short flight of stairs from the tiny foyer leads up to the double doors on the right and into the Cook Memorial Room.

The decoration of the Cook Memorial Room is very much in the Tudor style used for the Student-Faculty Lounge, but most of the decorative motifs are fresh rather than repetitions of those seen elsewhere. The room is rectangular, with a fireplace on the long entrance wall. On the opposite long wall is a shallow bay window projecting into the Quadrangle. This is flanked by vertical lancet windows; an additional pair of lancets opens the short end wall to the right of the entrance. So much window area makes the room, of modest dimensions, appear light filled and welcoming.

The focal point of the room is the full-length standing portrait of John Potter Cook that hangs on the end wall to the left of the entrance. The oil painting is signed and dated at the lower right: Henry Caro-Delvaille 1917. Since Cook's father died in 1884, the portrait was clearly not painted from life. But most surprisingly, the painting shows him as a young man of no more than twenty-five or thirty years. It is possible that Caro-Delvaille based the portrait on an earlier one painted in John P. Cook's youth. Or it could be that the portrait is entirely idealized, without pretense of resemblance to the sitter.

Though the painting may not be a portrait likeness, it follows a long portrait tradition of including within the picture attributes that convey information about the interests and occupation of the sitter. Cook is shown standing, presumably in his study, in formal black attire. A top hat and gray opera cape lie on an oval-backed chair in the foreground. Cook holds a book in his left hand, fingers marking his place, as though just interrupted at his reading. His right elbow leans on an open secretarial desk behind him, on which a globe and a miniature (perhaps of his wife?) are displayed. A tall wooden bookcase fills the right portion of the picture. Cook's gaze is confident, even piercing, as he looks out toward the viewer, and everything in the picture is meant to speak of a well-educated and formidable personage. The commemorative character of the portrait and of the room is underscored by a handwritten letter

from John P. Cook to his son that is displayed with the painting, inserted behind the glass that covers the portrait just above the artist's signature. The letter is dated at Hillsdale, Michigan, 16 April 1875, and begins: "My boy William, seventeen years old." It describes the elder Cook's concern for the future course of his son's life, and his conviction that the young man will succeed if he adheres to the values of morality, virtue, industry, and economy that he has already exhibited.

The walls of the Cook Memorial Room are paneled in carved oak wainscoting. The entrance to the room on the inner side has been given a handsome wood frame consisting of a classical cornice resting on fluted pilasters. This gives a restrained and sober definition to the doorway while blending unobtrusively into the continuous paneling of the rest of the room. The fireplace of white Indiana limestone is set into a projecting oaken casement of monumental proportions, ornamented with vertical panels, each of which is carved with a linenfold motif characteristic of Tudor domestic interior woodwork, as in the house at Deene Park, Northamptonshire.

The windows of the Cook Memorial Room, like those throughout the Quadrangle buildings, are a mosaic of pale gold, mauve, and clear glass below with symbolic roundels in the upper portion. The colored elements are of a particular brilliance, intensity, and beauty in this set of windows. The nine roundels in the Cook Memorial Room windows form a series with heraldic and allegorical motifs representing the various divisions of the law. Religious Law, for example, is symbolized by a grouping of five books with ornate covers of red; Natural Law by a knight's visor and shield. The other divisions are Moral, Ceremonial, Common, International, Civil, and Statutory. The ninth roundel is the great seal of the State of Michigan, framed by a border with the words: John Potter Cook 1812–1884.

The room has a flat ceiling of ornate plaster, broken up into round medallions connected by a projecting grid of horizontal ribs. Each medallion contains a single floral motif or rosette at the center, while other foliate sprays and leafed rosettes are scattered in the intervening spaces. In Tudor style, the ceiling is monochrome, a rich cream color.

The Legal Research Building

The main entrance of the Legal Research Building, or Law Library, is on the north side of the building, where it can be entered directly from the Quadrangle. The entrance is a projecting one with double portals, separated in Gothic fashion by a trumeau, and with Gothic tracery and niches above. The stone entablature above the entrance, on the left side, carries the following inscription:

LAW EMBODIES THE WISDOM OF THE AGES ❧

PROGRESS COMES SLOWLY

The pendant location on the right side is carved with these words:

LEARNED AND CULTURED LAWYERS ARE

SAFEGUARDS OF THE REPUBLIC ❧

The Reading Room

The doors open into a spacious vestibule that communicates with the Reading Room directly ahead, as well as with the student lounge areas on the floor below, which are reached by going down the stairs to the left or the right. The Reading Room is close in plan, elevation, and decorative program to the Dining Hall, but its scale is so vast that its impact on the visitor is truly like that of a Gothic cathedral. It is both longer and wider than the Dining Hall—242 feet in length by 44 feet wide—while its ceiling is the same height above the floor—approximately 50 feet. The cathedral-like height is achieved, as in the Dining Hall, by means of a two-part elevation composed of solid ashlar walls of limestone below, supporting a clerestory (window) zone of enormous vertical dimension above. Like the Dining Hall, the Reading Room terminates at the east and west in a flat end wall opened up by a vast traceried window in English Perpendicular style. In the Reading Room, the architectural design gives special emphasis to these terminal windows, since each of them is preceded by a rectangular bay roofed with a perfect sexpartite Gothic vault unit in stone. These two stonevaulted end bays are visually distinguished from the remainder of the room by being recessed behind thick stone piers supporting entrance arches. On the

Facing page:
*Reading Room,
Law Library*

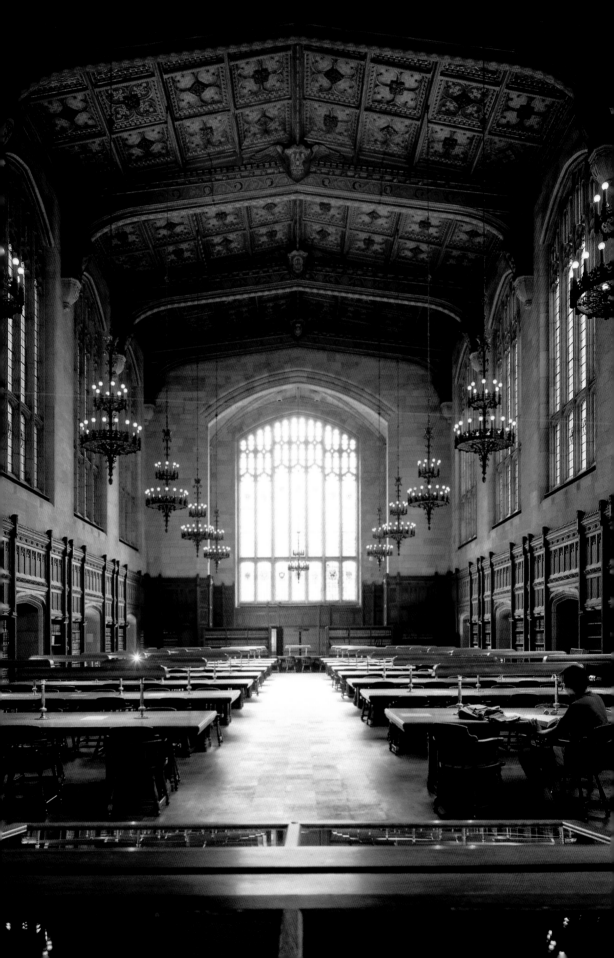

exterior of the building the two terminal bays are easily distinguished from the other eleven bays of the elongated Reading Room by the square towers that compress them from either side. These four corner towers were provided with consultation rooms that still display the ornate plaster ceilings that date to the original construction of the building. Today these elegant ceilings with their monochrome patterns in relief grace the offices of the Michigan Clinical Law Program, the Child Advocacy Clinic, and other offices.

The main Reading Room was designed to seat just over five hundred patrons. As in the rest of building, the floor of the room was laid with cork in order to muffle distracting noise. Reading alcoves opening into the main room on the north and south sides today provide additional study areas. These alcoves originally accommodated stack shelving to hold the twenty thousand or so volumes of statutes, reports, and reference books that were considered immediately essential for Reading Room users. All other books were dispensed through the Reference Desk from the six-level stack area behind the Reading Room. The disagreements that erupted over inclusion of this multistory stack zone, just as plans for the Legal Research Building were being finalized, were probably the most serious to arise during the life of the entire Quadrangle project.

As initially designed, the Legal Research Building made provision for only about 48,000 books, including those specialized collections to be housed in alcoves in the main Reading Room. Then-director of the Law Library, Hobart Coffey, supported by Dean Bates and President Little, insisted that the new Legal Research Building must accommodate at least 200,000 books, both to provide a much broader and deeper collection than that needed for ready reference and to allow room for future growth and expansion. Cook would have none of their arguments. He considered himself an authority on legal research, and he seemed to take his most intransigent positions on issues having to do with the Legal Research Building. On 28 July 1928 Cook drafted a long letter to Edward York in which he outlined his objections to the proposed "extension on the south," as he called it, that would allow for six levels of concentrated stack area. The final letter of 16 November 1928 that he

Chandelier, Reading Room

sent to York is considerably toned down but essentially makes the same points contained in the draft. Regarding the "extension," Cook objected that: "The great reason for postponing for two or three years its construction is that no one can tell now (a) how much of it should be used for books; (b) how much for student desks; (c) how much for research rooms." In regard to the problem of increased stack capacity, the point on

113

View from a Reading Room alcove, looking north into the Quad

which the library and faculty could see no compromise, Cook said this:

> (a) Books. The proposed extension has gone wild on this. It provides (including shelves on first floor of main building for 48,250 books), stacks, etc., for 200,150 books. Their law library at present has 70,000 books. It may be twenty-five

years before they have 200,000. In the year ended June, 1927, only 2546 law books were added to their law library. Law books are not produced so profusely as literary books. That stack capacity is altogether too great. Part of the space should be devoted to more seats for students and perhaps more research room and nothing but a few years' experience can solve this.

Cook then suggested providing for the problem of a growing book collection by utilizing the basement. Though he omitted this from his November letter to York, it is clear in the draft of 28 July that reducing costs was also a major factor in Cook's objection to the immediate construction of a stack "extension."

Despite Cook's objections, the Legal Research Building, completed in 1931, several months after Cook's death in 1930, was constructed with a six-level stack "extension" on the south side. Even with this provision, as early as 1946, Hobart Coffey, still director of the Law Library, was recording in his annual reports that the book collection had passed the 200,000 mark and that lack of storage space would soon reach a crisis. Subsequently in the mid-1950s four levels were added to the existing stack structure, creating a ten-level tower. Its stacks and offices communicate with the main Reading Room, but it appears as what it is—an adjunct to the original design, not an integral part of it. When the upper stack stories were built, the enclosed bridge was also added between stack Level 7 and the third floor of Hutchins Hall. The aluminum panels girding the exterior of the stack addition have drawn much criticism over the years. But with the economic realities of the 1950s, the era of Bedford granite and hand-laid stone already belonged to the past.

Expansion of the Law Library's stack capacity through construction of the underground Allan F. and Alene Smith Library Addition has permitted the alcoves of the main Reading Room to be given over to additional study area. These lateral spaces, in actuality, are not constructed as separate alcoves. Rather, the space on each side of the Reading Room is one long aisle, divided into alcoves by bookcases. If viewed from the outside of the building, it can be seen that the alcoves form the "chapels" that would be found tucked between the great buttresses of a

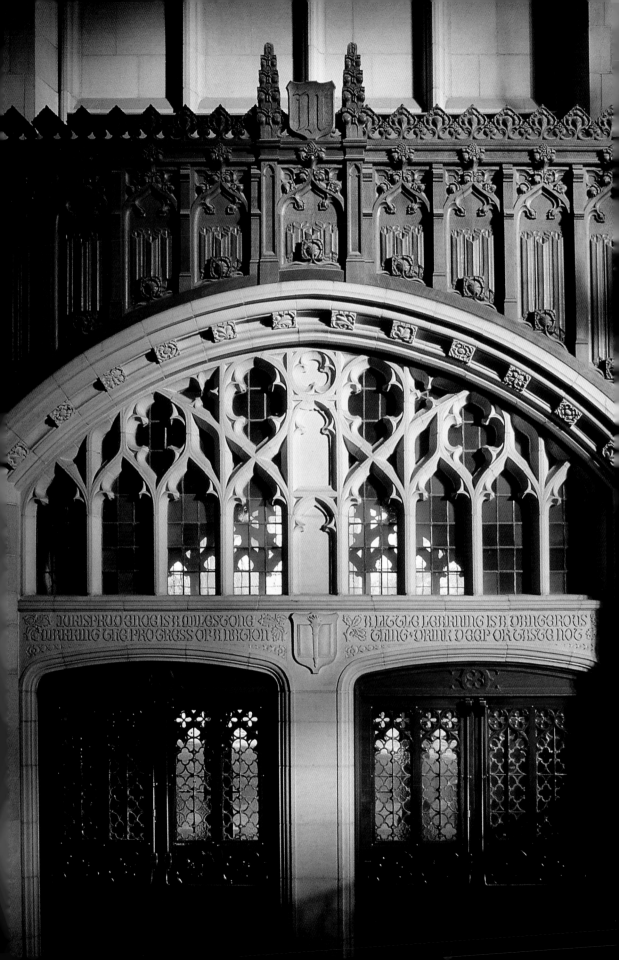

Medieval cathedral. On the interior, the visitor can see the curve of these great buttresses forming the roofing of the reading alcoves. The space between the stone buttresses is roofed with pitched timbers, painted and gilded with decorative medallions befitting the late Gothic theme of the building and its interior.

This decorative scheme, once again, is related to that of the late Gothic-style Dining Hall, but on a grander scale. The Reading Room, like the Dining Hall, is given richness and warmth by the finely carved pollard oak wainscoting that masks the limestone walls to a height of fifteen feet. The wainscoting of the Reading Room shares many motifs with the carved wood of the Dining Hall but is even more elaborate, since it includes figurative motifs, namely, heads of bearded men and animals of Gothic grotesquery, projecting at unexpected places.

The windows of the Reading Room are of similar design to those of the Dining Hall but have somewhat more robust and simpler tracery patterns. This more robust design is in proportion to the larger scale of the library, as is the two-tiered design of its twenty-two wrought iron, cathedral-style chandeliers. As in the Dining Hall (and in authentic late Gothic style) the window openings of the Reading Room are filled with grisaille glass of pale gray and gold or frosted white, accented with seals of burning color, representing the principal colleges and universities of the world.

The ceiling of the Reading Room is appropriate to the grandeur of the enormous space, opened by towering grids of glass and with its magically suspended chandeliers. The wooden ceiling is not of hammerbeam construction, like the one in the Dining Hall, but is a simpler timber truss roof. The roof was formed by laying down a series of enormous horizontal beams, the end of each beam resting on a stone cul-de-lampe that is bonded into the limestone coursing of the wall for strength. Each of the giant ceiling beams has been carved at its midpoint with a winged shield that has a coat of arms painted on it. The end of each beam, on its inner curve, is carved with a griffin holding an escutcheon. Finally, the areas between the beams have been divided into coffers (recessed square panels) framed

Facing page:
*Doorway from vestibule
into the Reading Room, seen
from the Reading Room*

117

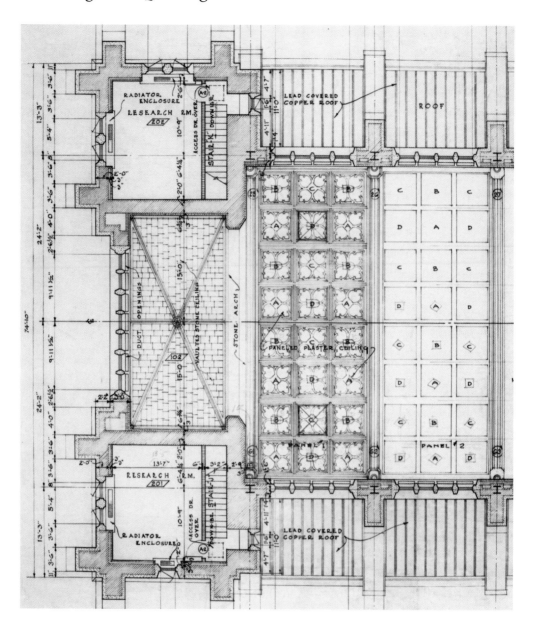

York & Sawyer drawing for ceiling of Reading Room

in wood and ornamented with denticulation on the inner side of the frame. The coffers are painted in blues and ivories, while the inner surfaces of the beams are painted in Gothic red with ivory or gold motifs. This splendid use of color and gilt paint will remind the visitor of the ceiling of the lobby of the Lawyers Club, while the decoration of the ceiling beams with monumental wood carvings recalls the treatment of the Lawyers Club Dining Hall.

Stack Levels 1 and 2 of the "extension" correspond to the basement level of the main Legal Research Building, where various facilities for students are located today—copying and computer services, a snack bar, and tunnels to Hutchins Hall and the Allan F. and Alene Smith Library Addition. Stack Levels 3 through 8 correspond to the towering ground story of the main Reading Room, while Level 9 approximately corresponds to the top story of the Legal Research Building (called the 9th Floor). Stack Level 10 rises above the height of Legal Research, though not above the height of its pitched roof. In fact, the correspondences between the levels of the stack "extension" and the main Legal Research Building are not easy to grasp, in part because the stack levels are not uniform, those added in the 1950s—Levels 7 through 10—being greater in height than the early levels.

Visitors can reach the 9th Floor of Legal Research by way of elevators in the lobby of the main Reading Room, to the east of the main desk. This floor houses thirty-two faculty and research offices, as well as two rooms of special interest.

The Cook Library

Room 903 is the Cook Library, furnished as a re-creation of William W. Cook's personal library in his private home in Manhattan. The idea of commemorating Cook's donation in this cultivated manner seems to have been Philip Sawyer's. He and Cook discussed plans for the room in letters of 30 July and 2 August 1929. The room is used today as a study for visiting scholars and for holding small meetings and luncheons. The rectangular room is rich and decorative but small enough in scale to feel cozy. The dominant features are the floor-to-ceiling oak wainscoting and a dramatic glazed skylight. The visitor will have noted the use of wainscoting throughout the buildings of the Quadrangle, where it is invariably carved with a Gothic flamboyance of detail. In the Cook Library the wood paneling is of a much more subdued style, almost devoid of ornament. This style succeeds in highlighting broad expanses of smooth, polished wood surfaces, rather than handcarved decorative work. The only decorated portion is the outer doorjamb, carved with beds of curled acanthus leaves.

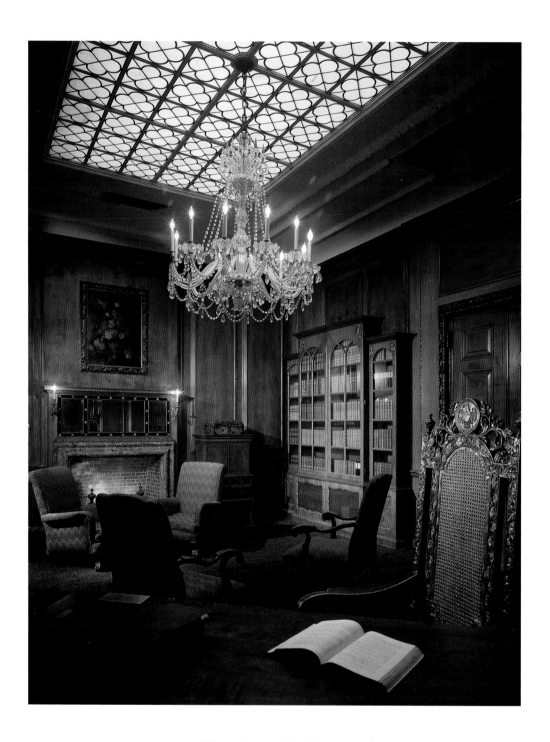



The Cook Library, Legal Research Building

The ceiling of the library is of ivory painted plaster. The entire center of the ceiling is opened up by a skylight divided into square panels forming quadripartite medallions held within a framework of tracery. Like the glazing found elsewhere in the Quadrangle buildings, the individual panels are grayish or pale yellow to achieve the plentiful light of late Gothic glass.

A great chandelier with swags of dripping glass beads and faceted oval drops is suspended from the center of the skylight.

As for the furnishings of the room, wooden bookshelves with glass doors line the walls and hold Cook's personal library. No legal tomes are found here, but rather richly bound volumes of classical literature—Shakespeare, the Waverley novels, Jules Verne, and others. The massive desk that sits diagonally across one corner of the room was not Cook's. Solid mahogany and carved over its entire surface with foliate vinework of a Baroque exuberance, it belonged to Elias Finley Johnson, a former member of the Michigan Law faculty. Johnson had ordered it made in the Philippines while he was High Commissioner there. The desk was donated to the Law School in 1982 by his daughter-in-law, Irene B. Johnson. A companion desk, made for William H. Taft, one-time governor general of the Philippines, is now at the Bentley Historical Library at the University of Michigan. Near the desk two wall sconces mimic the beaded and crystalline ornament of the central chandelier.

Equally eye-catching for its ornamental splendor is the mantlepiece on the opposite side of the room (to the visitor's right upon entering). The mantle itself is made up of three mammoth pieces of gray opalescent marble of a wonderful smoothness and density. An unpolished, monolithic block of the same marble forms the hearthstone. Above the mantle and resting on a frieze of carved wood is a mirror of triptych form with rectangular central panel and shorter side panels, the whole framed by a striking border of blue iridescent glass studded with four-petaled rosettes.

Several small works of art from Cook's Manhattan library complete the decoration of the room. Above the fireplace hangs an oil painting of flowers overflowing a vase. Of tall rectangular format, the painting is set within an ornate frame that appears to have been made for it by the same craftsmen who produced the wood carving around the entrance door. Unsigned and of indeterminate date, the painting follows a well-established eighteenth-century still-life formula. Nearby sits a small lidded casket of wood, resting on an armoire designed along classical lines. The casket is brightly painted and lacquered and depicts Biblical scenes. The style suggests it

is a work of popular art, combining traditional elements common to Coptic, Syrian, and Islamic art, used on objects made for sale to Western visitors to the Holy Land in the eighteenth and nineteenth centuries.

A fire of undetermined origin occurred in the Cook Library in the early 1960s. Fortunately damage was confined mostly to some minor furnishings and to ornate woodcarving, much of it gilded, surrounding the still life.

The Herbert Sott Seminar Room

Room 951, formerly a small faculty library, was converted to its present use as a seminar room with funds from members of the firm of Barvis, Sott, Denn, and Driker, and other friends of Herbert Sott. It accommodates groups of approximately twenty-four to twenty-five participants.

Despite its change in function, many distinctive features of the room have been retained from the early 1930s. The lustrous deep purple and black-veined Tennessee marble that borders the floor of the room associates its conception and execution with those of other rooms on the ninth floor of the Legal Research Building and with the adjacent hallway, where the original flooring is also intact. Even the baseboard of room 951 is faced with the same purple-black marble. Old-fashioned visor-like study lamps, mounted on the walls by long curving struts, contribute to the period style of the room.

Most notably, the ceiling and its large skylight have been left intact. The ceiling is of the ivory painted plaster used throughout the Quadrangle for rooms of small to moderate dimensions, from the Cook Memorial Room to some of the office spaces adjoining the Reading Room of the Legal Research Building. In the Herbert Sott Seminar Room, a very delicate low relief has been used to create monochrome patterns on the surface of the ceiling, incorporating some of the same motifs present in the ceiling of the Lawyers Club Lounge—foliate rinceaux bearing a single rosette, clusters of grapes or acorns. These forms adorn a cornice framing the skylight, while other motifs appear to emerge from the four corners. The skylight is virtually identical to the one in the Cook Library.

*Door from inner courtyard
to north corridor, first floor,
Hutchins Hall*

Hutchins Hall

Hutchins Hall is the main classroom building and administrative center of the Law School. It has been frequently remarked that Hutchins, the last of the buildings of the Quadrangle to be constructed, lacks some of the refinements and historical details of the other three. This has been attributed both to financial constraints and to the requirements of its teaching and administrative functions. It is true that the interior expanses of Hutchins Hall appear less varied in their display of materials and more spare in handwork than the earlier

123

buildings. Nevertheless, Hutchins has its own considerable distinction as a work of architecture. The design of the building, with classrooms grouped around an enclosed inner courtyard, is an ingenious replication of the Quadrangle design itself, amplified by the inclusion within the scheme of yet another semi-enclosed courtyard between Hutchins Hall and the Legal Research Building. This ensemble of elements creates, within the principal corridors of Hutchins Hall, a complexity of space and light infiltration not encountered in any of the other buildings of the Quad.

The first two floors of Hutchins Hall are occupied by classrooms and seminar rooms. The third and fourth floors contain administrative and faculty offices, as well as the Faculty Lounge. The basement level of the building connects by a pedestrian tunnel to the Legal Research Building. The serene core of Hutchins Hall, and the source of its natural light, is the rectangular inner courtyard, contained by high, vine-covered walls on all sides but open to the sky and, in the milder seasons, adorned with a rambling growth of foliage and other greenery. One of the most enchanting spots on campus, the courtyard has often been the site of receptions and student and faculty weddings. The visitor can enter this enclosed natural retreat from doors in the north and east corridors of Hutchins Hall. The ground-floor classrooms are grouped along the west and south corridors that frame the courtyard, with the addition of two large lecture rooms projecting to the north and east—the Jason L. Honigman Auditorium and Room 150.

The principal entrances into Hutchins Hall are on the north, west, and south, opening from the Quadrangle, State Street, and Monroe Street, respectively. All three entrances have been given elaborate treatment on the interior, in the manner of the Gothic portals of the Dining Hall and the Legal Research Building. Entering Hutchins Hall from Monroe Street and turning back to view the double portal from the interior, the visitor will be struck by the inspiration from Gothic church design and the authenticity with which it has been carried out. Rich wood paneling and a low wooden ceiling enclose and protect the vestibule, creating a flooring for a kind of dwarf second story above the entrance, very much like the organ loft above a

Facing page:
East corridor, first floor Hutchins Hall, looking from Monroe Street entrance to entrance from the Quad

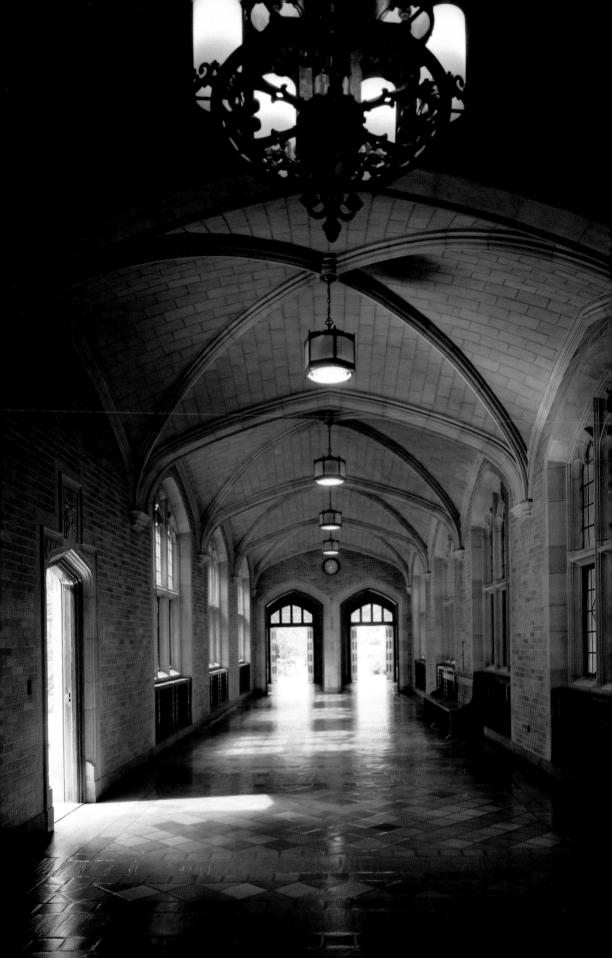

Medieval church entrance. A traceried window in the entrance wall spills natural light into the corridor.

The Monroe Street entrance faces an even grander double portal at the opposite end of the east corridor. This is the main entrance into Hutchins Hall from the Quadrangle. The situation of the Quadrangle entrance in the spacious intersection of the north and east corridors gives it a special focus and grandeur. From the exterior, an open stone portico with monumental inscription above it shields the approaching visitor from the elements (see the description of the exterior of Hutchins Hall in chapter 1). Passing into Hutchins Hall through the double doors, the visitor stands beneath a great quadripartite Gothic vault suggestive of a domed space. Proceeding into the wide east corridor and looking back at the portal, the visitor is greeted by a bronze plaque affixed to the pier that divides the great double portal into two openings. Inscribed on it is an excerpt from the will of William Wilson Cook:

> Believing as I do, that American institutions are of more consequence than the wealth or power of the country; and believing that the preservation and development of these institutions have been, are, and will continue to be under the leadership of the legal profession; and believing also that the future of America depends largely on that profession; and believing that the character of the law schools determines the character of the legal profession, I wish to aid in enlarging the scope and improving the standards of the law schools by aiding the one from which I graduated, namely the Law School of the University of Michigan.

As the visitor faces the portal from the interior, a flight of broad steps to the right leads down to the corridor of Level 1 of the Legal Research Building.

The spacious corridors that frame the inner courtyard are each composed of a horizontal sequence of identical spatial units (or bays), each bay covered by a four-part Gothic ribbed vault. The structural framework of the building on the interior—the piers, arches, and ribs—was entirely constructed of white ashlar limestone, while the solid masonry walls—the

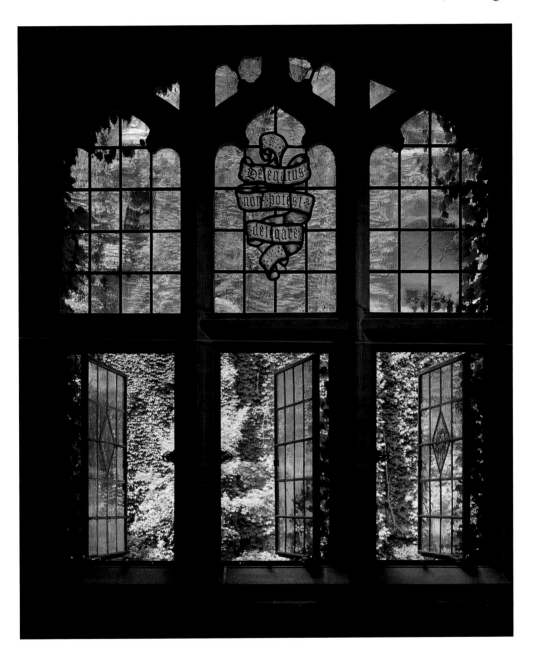

"webbing," so to speak, that fills in this framework—was built of thin, light-hued bricks. At each of the corridor intersections, identical wrought-iron wheel chandeliers of six lights are suspended from the ribbed vault. The presence of the courtyard allows the inner walls of the corridors on the courtyard side to be composed almost entirely of glass. Each giant window unit,

Grisaille glass, cloister corridor, Hutchins Hall

contained within a pointed Gothic arch, is divided vertically by tracery into three lights, each of which is further subdivided, above and below, into three smaller glass panels. Sequential segmentation of the window into smaller and smaller units is highly characteristic of Gothic window construction and suggests that the modern craftsmen who created these windows understood the geometric basis known to underlie Gothic design. Of all the corridors in Hutchins Hall, the east hallway that runs between the Quadrangle and Monroe Street entrances is particularly translucent, since it receives natural light from both sides, one expanse of windows opening onto the Inner Courtyard and the other onto an L-shaped courtyard between Hutchins Hall and the Legal Research Building.

The Gothic windows of Hutchins Hall contain the same grisaille glass used throughout the Quadrangle, predominantly frosted white panes mixed with palest blue, rose, and gold ones for maximum light. But the windows in the corridors of Hutchins Hall are unique. Set within them are panels of geometric shapes—quatrefoils, diamonds, and ovals—painted

The Michigan Law Quadrangle

with small vignettes representing the categories of crime and the divisions of the law. These allegories are found in the windows of the north, south, and east corridors, and the visitor who discovers them will be delighted by the unexpected whimsy of the series. The vignettes are painted in grisaille tones—sepia and gold against clear glass. The tableaux are very small in scale, painted with a sketchlike rapidity resembling drawing more than painting and done in a highly naturalistic style. Miniature scenes such as these would not have been feasible in most contexts in the Quad, but here they are perfectly placed at eye level, inviting an intimate scrutiny of the scenes.

The visitor will be amused both by the subject matter and the style of the scenes. They seem incongruously modern in the context of the Gothic windows they inhabit, since most of the costumes and the style are thoroughly of the period in which they were painted, the 1930s. But these same features give them a quaint, dated quality suggestive of raccoon coats and the first emergence of the college student as a stereotype of American youth. The sequences along either side of the east corridor rep-

resent crimes of varying seriousness, but all are depicted with broad caricature and humor. Manslaughter and Gambling are there, Mayhem (represented by a football analogy of roughing the kicker), Burglary, Conspiracy, Forgery (an artist copying a Rembrandt self-portrait), Disguise (a woman being transformed in a beauty parlor), Receiving Stolen Goods (a knickered boy presenting flowers to his teacher), Petty Larceny (babies raiding jam jars!), and others. In a few of the panels, such as Burglary and Contracts, the artist has attempted to lighten the message by depicting the vignette in the costumes and setting of another century, as though presenting a theater piece. Honor is represented by a duel and Murder by a man shooting a bird. In the windows of the north corridor, paralleling the Quadrangle, two of the scenes appear to depict the Law Quad itself. In one, titled Malicious Mischief, three students (presumably University of Michigan students) are shown climbing a pole to change the street sign from Monroe to Main Street. The walls of the Law Quadrangle are sketched in summary fashion behind. Another vignette shows a male student, wearing a Michigan sweater, standing with two women in front of the Quadrangle entrance into Hutchins Hall.

The Faculty Lounge, or Faculty Common Room (Room 350)

The administrative hub of the Law School, including the Office of the Dean, is located on the third floor of Hutchins Hall, along with other faculty and staff offices. Between 1980 and 1982 the southeast corner of the floor was renovated to form the Faculty Lounge (or Common Room). Previously this area had been a closed faculty library, which was relocated in 1981 to Level 8 of the Legal Research Building. The renovation was instituted by the Capital Improvements Committee and made possible by funds from the bequest of Julian A. Wolfson, LL.B. '09. Mark Hampton, a New York interior designer specializing in traditional and historic decoration and who had been a student at the Michigan Law School twenty years earlier, was selected to carry out the renovation. Hampton based his treatment of the space around certain ideas and associations that the concept of a commons room called up for the Law School faculty. Most important was the idea that the room must foster collegiality,

community, and a sense of shared purpose among those who used the room. In this respect, tradition played a strong role. The faculty expressed its desire to include a round table—in both the literal and figurative sense—as the one required element in the room's furnishings, since a table of that type had been so important as a gathering place in the old Faculty Lounge. With these general themes as starting points Hampton created a Common Room that is both comfortable and personal, even as it emphasizes the dramatic spatial features of the room.

The Faculty Lounge is entered from the adjacent corridor by way of formal double doors, but the lightness and lofty proportions of the room are not visible until the visitor steps around the partition that immediately greets him as he enters. Because of its corner placement, the room is lighted by tall Gothic windows in two walls. The ceiling is pitched like an attic but soars two stories overhead, reinforcing the sensation that one is perched among the rooftops.

On the interior side of the entrance partition, facing into the room, is a wooden bookshelf serving for the display of a collection of Chinese vases, most of them appearing to date to the nineteenth century. In front of this, on a wooden pedestal, stands a bronze bust of Thomas M. Cooley, LL.D., presented by the Law Class of 1895. Across the room from this display and flanking the large central lancet window, on wooden cul-de-lampes placed up high, are two marble busts mimicking Roman portrait style (that is, the sitter is nude with shoulders loosely draped in a toga). The bust at the left is Rousseau and at the right is Voltaire. A photograph in *A Book of the Law Quadrangle* (p. 43) shows that both the busts and the Chinese vases were originally displayed in the replica of William W. Cook's Manhattan library on the ninth floor of the Legal Research Building. Hence they originate from his private art collection; they were moved to the present Faculty Lounge in approximately 1984.

Curio cabinets and bookshelves on the room's north wall display other small works of art and book collections. But the focal points of the room are the two Renaissance tapestries that hang against the north wall. These are two of the three

Larger of two game park tapestries given originally to the Lawyers Club by William Cook

tapestries mentioned earlier in this chapter as having been bequeathed to the Law School by Cook and that formerly hung in his own Manhattan townhouse. After one of the tapestries was stolen in 1972 (but fortunately recovered some five or six years later), concern for their safety forced their relocation to more secure surroundings. The earliest of the three tapestries, now stored at the University of Michigan Museum of Art, is considered the most valuable. It is usually dated to the second half of the fifteenth century and is identified as French, while the two later ones are Flemish, attributed to Brussels. All three tapestries depict secular hunting themes, but the fifteenth-century one is more formal and even ceremonial in its arrangement of figures. It represents a man holding a hooded falcon on his wrist. A woman at the center greets a male and female couple approaching from the right. Hunting dogs and a flower-filled landscape background add the final traditional elements to this Gothic conception of the hunt.

The other two tapestries are of larger dimensions and of a later, more exuberant style. They were probably produced in one of the fine tapestry workshops of Brussels in the first half of

Fanciful beasts of the smaller game park tapestry

the sixteenth century and may have been designed as part of the same ensemble. They are both described as "Game Park" tapestries for their depiction of fantasy woodland parks teeming with animals and foliage of every variety and in which humans are given a pictorially subordinate role. The smaller of the two hangings is a vertical rectangle, while the larger one is horizontal. Both have been considerably cut down and pieced back together over the years—not an uncommon treatment for wall hangings—so that viewers can only try to imagine the original dimensions of the tapestries and how much has been lost of each. While it seems obvious they could never have been a pair, it is just as clear, based on the style and imagery of the two and their complementary borders, that they must have belonged to the same series of tapestries, done in the same style but in various sizes and formats and designed for specific locations within the home of the patron who commissioned them.

The smaller of the Renaissance tapestries (the one stolen and recovered) features an exotic hybrid animal (a combination of armadillo and crocodile) in the foreground, fending off a dog. A vine-entwirled tree at the left adds to the slightly sinister note of the combat. At the very far left is depicted a bedraggled lion with a sheepish, almost human face. A full hunting party with hounds is shown farther back, set within a green and verdant northern landscape. Most distant of all are the spires and houses of an enormous city in the far background. The secular character of the tapestry's subject matter is underscored by the imagery in the wide decorative border that frames the narrative scene in the center. The Renaissance character of the wall hanging is clear in the motifs chosen: vases sprouting lush fruit, Roman deities, such as Europa and the Bull and Apollo in his chariot. All derive from Greek and Roman antiquity.

The second tapestry uses a similar pictorial strategy, push-

ing the main stag hunt to the middle ground, with hounds and horsemen closing in for the kill, while more exotic and even disturbing scenes of animal predation are displayed in the foreground—a she-wolf and her cubs being menaced by a leopard, and a wolf carrying off a slaughtered ram over its back. This example has a similarly rich border of fruit, foliage, and classical allegorical figures. Both tapestries use a rich spectrum of colors—blue, green, red, brown, and buff and are woven of wool, silk, and gilt threads.

The Classrooms

The first and second floors of Hutchins Hall contain the Law School classrooms, planned to accommodate a variety of teaching and learning functions. Between 1984 and 1994 many of the rooms were substantially renovated, prompted by three primary objectives: to accommodate changes in Law School curriculum; to bring the rooms up to a higher functional standard; and to bring to these rooms a kind of interior richness characteristic of the rest of the Quadrangle, a style that origi-

nally could not be extended to Hutchins Hall. It was Dean Lee Bollinger who envisioned the refurbishing of the classrooms in a style reminiscent of the Cook era and expanded the fund-raising efforts begun by his predecessor, Terrance Sandalow.

THE JASON L. HONIGMAN AUDITORIUM

The 372-seat Jason L. Honigman Auditorium (Room 100), opening from the the north corridor, was renovated in 1987–88 with donations from the Honigman Family Foundation and members of the firm of Honigman, Miller, Schwartz, and Cohn. The recent changes were intended to give this large auditorium greater flexibility, making it suitable for medium-sized classes of one hundred, as well as for major functions at the Law School. There is no dais at the focus of the room, but there is a large rostrum seating as many as six speakers. The first seven tiers of seats and writing surfaces closest to the rostrum are of the continuously curved amphitheater design also found in Room 150, with matching oak chairs. The remaining tiers were replaced with upholstered auditorium-style theater seats.

Alterations to the surfaces of the room and to the speakers' area were introduced to achieve a high level of acoustical quality. A projecting acoustical panel or "cloud" with lights was suspended over the speakers' rostrum and acoustical panels were mounted against the back walls of the room. A control center for the use of a technician operating the audio and video equipment of the room was installed near the back of the auditorium. At the same time, a sense of greater richness was achieved through the addition of the upholstered seats, the carpeting, and the large, frosted glass light fixtures composed of glass demi-globes rimmed with bronze.

ROOM 116

The renovation of Room 116, which seats seventy-two, was designed by Ann Arbor architect David Osler and was funded by the university. The earliest of the classrooms to be renovated (in 1978), Room 116 underwent alterations intended to eliminate noise from South State Street, to facilitate discussion among students, and to remove the barrier between instructor

and students created by the traditional elevated dais arrangement. The result, however, is a windowless room in which natural light had to be sacrificed to noise concerns.

THE HERBERT M. KOHN AND THOMAS W. VAN DYKE SEMINAR ROOM (ROOM 118)

Long and narrow, Room 118 seats twenty. The room was renovated in 1985 when it was transformed from the former Alumni Room to a functional seminar space with gifts from Herbert M. Kohn and Thomas W. Van Dyke. The small scale and scholastic seriousness of the room are nevertheless bestowed with grandeur by the presence of the magnificent four-part lancet window with Gothic tracery that opens up the entire end wall of the tiny room.

THE SQUIRES, SANDERS, AND DEMPSEY CLASSROOM (ROOM 120)

Room 120 was completely renovated in 1991. The focus of the room is the wide pointed arch of broken section that frames the dais area. The arch was part of the renovation, and efforts were made to harmonize this major structural feature with the original design of the room, using white ashlar limestone. The interior of the room was given a richness of decoration throughout, from the rusticated plaster walls painted deep blue and contrasted with the white limestone trim, to the deep blue carpeting and draperies. The ceiling is segmented by fine, elegant ribs painted Gothic red and picked out in gilding. While much modernized, this scheme recalls the beautiful painted and plastered ceilings seen in the earliest parts of the Law Quadrangle, as do the dramatic glass ceiling lamps suspended from wrought iron fixtures. The renovation was designed by architects Quinn, Evans. It is the first classroom renovation funded by donations only from Michigan Law alumni within a firm (rather than from law firm funds).

THE VARNUM, RIDDERING, SCHMIDT, AND HOWLETT CLASSROOM (ROOM 132)

Seating sixty-seven, Room 132 has been thoroughly transformed in a recent renovation. Through the abundant use of

Facing page:
Room 132, a renovated classroom in Hutchins Hall

carved wood, and in the decorative motifs employed, Room 132 now has the most Medieval aura of all the renovated classrooms and is most reminiscent of the rooms elsewhere in the Law Quad that were completed during Cook's era. The focal point of the room is the handsome proscenium arch that acts as a frame for the dais and rostrum. Constructed of carved wood, the arch is built up of projecting and receding elements conceived on a monumental scale. Flanking the arch are projecting vertical panels of architectural scale decorated at the top with typical late Gothic decorative motifs—ogee arches (arches of reverse S-curve) and trefoil designs (groups of three circlets)— all carved as delicate wood tracery in approximation of Gothic wood carving practices. In the spandrels above the limestone arch that the wooden proscenium enframes, single rosettes are carved, extending the motif of the Tudor rose to this classroom building, even as it appears in many of the early rooms of the Quadrangle.

The wooden dais is decorated with recessed devices of Gothic design picked out in Gothic red, blue, and gray, and these same motifs appear on the wooden portions of the redesigned ceiling. As part of the renovation, the ceiling was broken up by a wooden framework, installed to mask air conditioning ductwork. The strategy, in fact, achieved a dual success, since the ceiling now appears to be supported by massive wooden beams with details picked out in red and gilt paint, while it coordinates in these same features with the architectural arch at the focus of the room. The back of Room 132 has a wood-paneled framework of architectural scale mirroring that of the dais area but without the proscenium arch. The walls and carpeting of the room are sage green. Hanging lamps are supported by wrought iron armatures similar to those in Room 120. This renovation also was the work of Quinn, Evans.

ROOM 150

Room 150 is notable precisely because it has been very little renovated. Therefore, more than any of the other classrooms, it best preserves the appearance of the large lecture rooms at the time Hutchins Hall was first constructed. Furnishings are all of wood and spare, with a small raised dais for the lecturer

and tiers of curved writing tables and straight-backed chairs for the students. The metallic light fixtures are small and modest in design, and there is no carpeting. The room would appear starkly severe were it not for the tall lancet windows of Gothic design, grouped in pairs and triplets, that open up both long walls, giving onto Monroe Street on one side and the inner courtyard between Hutchins Hall and the Legal Research Building on the other.

THE PRACTICE COURT AND THE JURY ROOMS (ROOMS 232 AND 234)

The Moot Court Room was designed as a small-scale but fully equipped courtroom and jury deliberation room for use in the clinical programs of the Law School. In 1991–92 it was renovated with funds provided by the Class of 1955 in honor of its thirty-fifth reunion and by gifts from alumni to the Law School Fund. These funds made possible the fitting of the room with state-of-the-art video equipment, a fine audio system, air conditioning, and a movable podium that lets lawyers face the jury and judge separately. There are built-in microphones throughout the room and remote control cameras, even in the jury room.

THE ROBERT AND ANN AIKENS SEMINAR ROOM (ROOM 236)

The room seats forty-three people and was refurbished in 1988–89 with generous contributions from Robert and Ann Aikens. The space was given valuable flexibility for use as a seminar room as well as a more formal small classroom by the addition of an ingeniously designed table at floor level that converts from use as a first-row writing surface to a seminar conference table. The deep blue and rose tones of the Oriental-style carpet at the center of the floor are echoed in the deep navy blue of the drapes and the rusticated plaster walls of rose. Prominent features of the room are the two giant wheel candelabra, whose elaborate hanging armatures are suggestive in their patterns of early Medieval metalwork.

THE DYKEMA GOSSETT CLASSROOM
(ROOM 250)

This classroom seats 116 and was refurbished in 1989 with con-
tributions from alumni at the Dykema Gossett firm and from
the firm itself. It was the second in a series of similar renovations
and enrichments that includes rooms 100 and 120. Here the
walls have been given a rusticated plaster surface, painted sage
green, with sage green velvet draperies and coordinating carpet-
ing. The ceiling lamps are of the same giant saucer type used in
Room 100, while the painted detailing on the ceiling beams and
cornices pairs Gothic red with gilding, as in Room 120.

The Allan F. and Alene Smith
Library Addition

The latest addition to the architecture of the Law Quadrangle
differs from the other buildings not only in its ultramodern
design but also in its funding. In contrast to the Gothic build-
ings framing the Quadrangle, given in an unprecedented dona-
tion by a single individual, the Allan F. and Alene Smith Library
Addition was financed by a concerted fund-raising campaign
that involved large numbers of alumni and private donors.
Dean Theodore St. Antoine launched the multimillion-dollar
fund-raising effort in the 1970s in response to the critical space
shortage that had once again overtaken the Law Library in its
quarters in the Legal Research Building. Alumni were also
involved in the planning for the new library addition. There was
a general consensus among graduates of Michigan Law, as well
as among the faculty, that the architecture of the Quadrangle
was too unique and too precious to alter the experience of it by
interposing a modern building into the grouping. It was just as
clear that to attempt another building in the same style as
Cook's would be folly, given the modern costs of materials and
the loss of traditional skills in many of the building arts that had
given such an individual stamp to the Quadrangle buildings,
both inside and out.

In an ingenious solution, the Building Committee and its
chosen architect, Gunnar Birkerts, decided to put the new

Facing page:
Birkerts wrapped the Law
Library addition around the
Cook Legal Research Build-
ing "like a child at its
mother's knee," as he put it.
Light well as seen from top
level of Cook Building's
stacks

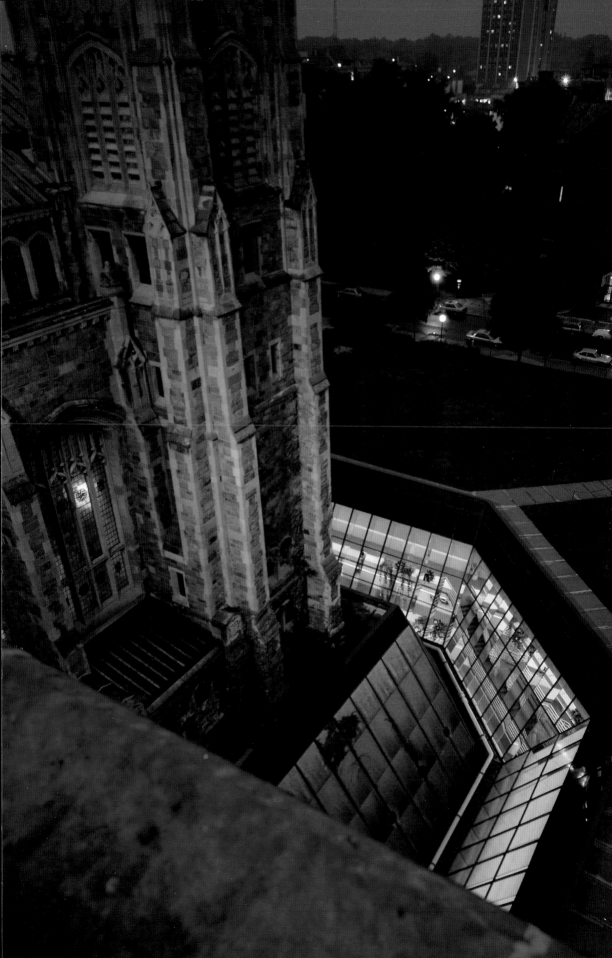

building below ground. This would enable Birkerts to incorporate every progressive design feature that modern architectural planning has at its disposal, along with the technological features desired by the library's users and staff, without destroying the equilibrium of the Quadrangle space and its Gothic-style buildings. Subterranean construction was not an unprecedented concept by the 1970s. Institutions and individuals had been experimenting with various kinds of structures, both as a response to space constrictions above ground and to calls for greater energy efficiency, well fulfilled by below-ground structures, which require significantly less energy to heat and cool than do above-ground buildings. The architectural solution reached by Birkerts at Michigan was, nevertheless, a bold and inspirational one that has been praised by the national and international communities for its success.

The most essential requirement from Birkert's point of view was that the building's design must flood the structure with daylight at all levels to negate any sensation for the building's users that they had been consigned underground. The main body of the library is of relatively conventional design, consisting of three layered stories sunken successively deeper below the surface and designed for concentrated stacks or administrative purposes. In plan the new building resembles a flying wedge or thickened L-shape, since it was required to fit around and to connect at the subterranean level with the southeast tower of Legal Research. To achieve a sense of daylight immersion in such a radically sunken space, Birkerts used a deep, V-shaped light well (sometimes called a moat) that defines the building on two sides and is faced with limestone panels on one side and reflective glass panels on the opposite slope. A steam pipe runs along the floor of the light well to keep it free from snow and ice accumulation. The light well penetrates only to the depth of Sublevel 1, but the sloping wall of limestone continues all the way to the base of Sublevel 3 and is the vital design feature in transmitting daylight from the light well to the lower levels of the building, where it is diffused throughout. From the exterior of the building at ground level this deep, cavernous light well with its mirrored surfaces is the only portion of the new library visible to the observer.

On the interior the breathtaking effects of space and luminosity are fully realized. A grand staircase takes the visitor from the Gothic Reading Room of Legal Research down three successive levels of the underground library. At each level, balconies along the main circulation route overlook the great light well. These are popular seating areas, since Birkerts chose to highlight them on the exterior with great mirrored panels set perpendicular to mullions, creating fascinating visual effects. Their surfaces reflect a perpetual kaleidoscope of foliage, sky, and shimmering images of the Gothic building towering over them.

The new building comprises 77,000 square feet and accommodates 180,000 volumes in the finished spaces. It is designed to hold another 200,000 to 300,000 volumes in storage. Among its forward-looking features are the 246 locked carrels, one provided to every student, which were wired from the outset with the capacity for on-line computer networking and display. The *Michigan Law Review* and the *Journal of Law Reform* have offices on Sublevel 3, while the office of the *Michigan Journal of International Legal Studies* is found on Sublevel 2.

Mirrored beams in the Library Addition keep images of the original building ever present in the new

Conclusion

Besides its monumental scale and its historical authenticity, that which most distinguishes the Michigan Law Quadrangle is its character as a self-sufficient residential school for legal studies. In this sense it provides an environment for its students and faculty that is unique among all other schools and colleges on the Michigan campus. The written record, while incomplete for the early period when the project was crystallizing, nevertheless indicates that the idea of a residential quadrangle was one that evolved from several different kernels and solidified quite rapidly.

Cook, it seems, had originally proposed to donate to the university a freshman dormitory. Designed by York & Sawyer, Cook's architects designate, the dormitory clearly was to have had a quadrangular plan. This project for some reason was abandoned. According to Dean Bates, when Cook subsequently learned that his former law school was in need of new quarters, he expressed his immediate interest in supporting such a project and asked President Hutchins to present him with a proposal. It is at this stage that the earliest—abandoned—idea of a quadrangular dormitory and dining hall seems to have been resurrected and combined with that of a Law School and Legal Research Building, to create a thoroughly integrated working and residential environment.

The basic concept responded to the European—and especially to the British—university tradition of concentrated study within the confines of a residential college unit. William Wilson Cook made it clear, however, that he foresaw an even larger role for the special environment he was providing for Michigan law students, the environment in which they would have the opportunity to pass their three years of legal studies. Cook

envisioned a living/working situation in which law students, through their easy contacts with faculty, with distinguished lecturers and practitioners of the law, and with one another, would forge early personal and professional relationships that would serve them for the whole of their professional careers.

Photo Credits

Balthazar Korab: p. 29

Law School Papers, Bentley Historical Library, University of Michigan: pp. 33, 34, 35, 53

Print Room archives, Facilities Planning and Design Office, University of Michigan (photographed by Photographic Services, University of Michigan): pp. 36, 37, 40, 41, 43, 86, 95, 99, 118

Cook Papers, Bentley Historical Library, University of Michigan: pp. 68, 84, 85, 87, 88, 89, 90, 91

American Architect [vol. 124, no. 2425 (Aug. 1923)]: pp. 77, 78

Architectural Review [vol. 16, no. 8 (Aug. 1909)]: p. 81

All other photographs by Gary Quesada.

Colophon

Designed by Wesley B. Tanner / Passim Editions
Typeset in 11/15 Adobe Garamond
with display in Caxton and Photina.
Printed by University of Michigan Printing Services
on Warren 80# LOE Dull.
Bound by Braun-Brumfield, Inc.
in ICG Pearl Linen cloth
with Rainbow Antique endsheets.